We can't stop thinking about the future

ARTIST ALEKSANDRA MIR
SPEAKS WITH THE SPACE WORLD

CONTENTS

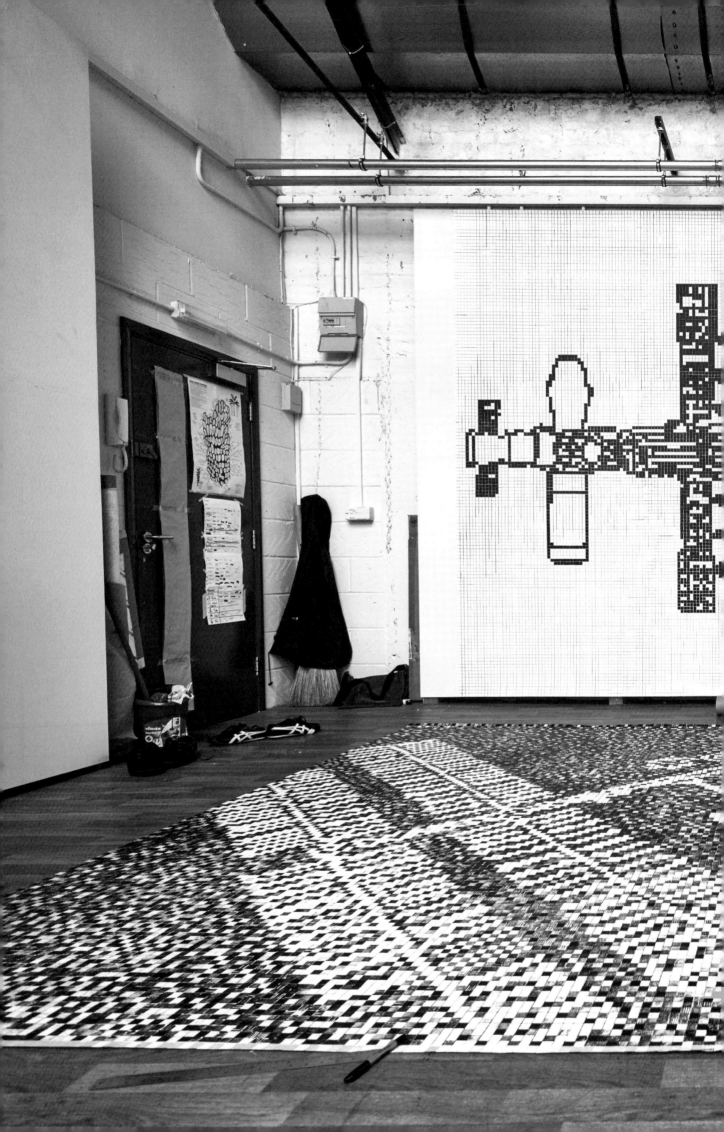

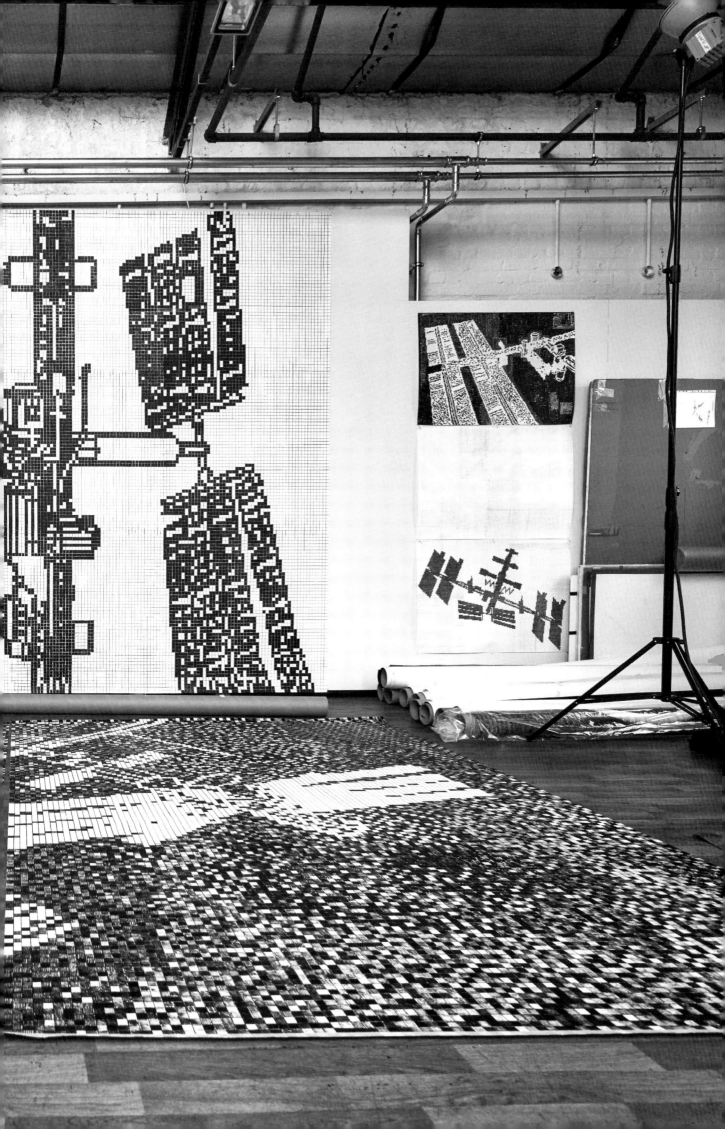

What came first, the big thing or the small thing?

HELEN FRASER is a dynamic Astrochemist, who exploits Microgravity conditions to test how planets form. She specialises in all things ice – ice chemistry and physics, how ice is formed in Space, its role in star and planet formation, and importance to the emergence of extra-terrestrial life. She heads the Astrochemistry group at the Open University, UK.

ALEKSANDRA: You are like a racecar driver who built her own custom made Ferrari, a vehicle for colliding ice particles during a series of parabolic flight experiments. It sounds dangerous and a bit sickening.

HELEN: If you don't like flying, don't listen. A parabolic flight goes up at a 50° angle. It flies through a curve which gives you 22 seconds of weightlessness. We bring our experiment into the plane, trying to collide small grains of ice together very slowly to see if they stick or not. The purpose is to simulate what is happening in the early stages of star and planet formation.

You have built a whole career around ice.

Ice is a big reservoir of material and it is where all the interesting chemistry happens. In the lab we can grow ice or make ice, we use telescopes to observe the ice in Space and we do simulations in the computer so we can try to understand it on molecular and atomic levels. A big part of my research right now is this simple question and simple experiment of what happens when two small pieces of ice stick together; but realising the experiment is complicated and answering the question of how we get from a couple of particles to a planet is also difficult. We know that when you get to kilometre size bodies, gravity takes over, but we don't know what came first, the big thing or the small thing. It is like the chicken and egg.

How do you resolve this philosophical dilemma?

For example, when we look at the particles in our experiment we see that when they bump into each other, some don't just stick, but spin around, like cars in a collision. Particles spinning will have an effect on what's coming behind, so you end up with a collection of particles, an ensemble that are somehow associated with each other and eventually coalesce. This has been a very big finding of our research. The technical term is *Streaming Instability*. I am not the one who first suggested it, but we were the ones who showed how this mechanism could happen in practice.

In art we are constantly preoccupied with the question of authorship, from the solitary genius to people feeding into and off each other in various ways. My own drawing project is a big experiment in that regard. I am guiding a group of people through a collaborative effort, relying on each of their unique responses to form the bigger picture. How do authorship and collective practice feature in science? When you say, *we*, who are *we*?

Science is not done in isolation these days. Generally we are encouraged to collaborate. The PhD students are in the labs every day working hard while I guide them through their theses. Over the course of the last ten years that this project has been running, in my group I have had six or seven PhD students who have fed into this big picture through either doing observation, simulations or experiments.

But first you design the experiment.

Yes, but these days I have the ideas and I have to secure the funding so I don't get to do much of the actual work in the labs. What also builds a nice team is the undertaking of the parabolic flight work. We rent a big house for everyone in Bordeaux for two weeks, spend time and cook for each other. We have one week of setting up the experiment, which is quite stressful, to make sure everything is going to work and on the actual flight days, we start at half five in the morning. We just want to be there for the science.

Are you holding the experiment on your lap?

The experiment gets bolted down. We are strapped in and they give us drugs to stop us from getting sick. It has the effect of a lot of gin and tonics. It disengages a part of your brain, so you don't get mixed messages between your hearing and vision. It makes you sleepy and dehydrated. The flight lasts for four hours and there is no toilet on board. If you need to go, you have to go in a water bottle. One person's job is only to start and stop the video camera, very simple but very important, so we can analyse the experiment afterwards. Another person's job is to press the button that fires off the pistons that will push the particles together and the third person's job is to turn a handle to set up the next set of particles. Somebody turns. Somebody presses a button. Job done. Camera watches everything. It is very, very simple.

How is a parabolic flight different from a regular flight?

We normally fly over the Mediterranean in military airspace. The plane is flying forwards and then starts tilting up. The French pilot tells us the angle, *30, 40* and at the point when we are going to hit the Zero G phase, he says *Injection* in a very nice French accent and at that point you feel yourself *losing your tummy*, like when you hit a bump in the road, but this is continuous.

For how long?

It lasts for 22 seconds. We do our experiment in that time and then we get a warning, *40, 30* and then he says *Pull Out*.

And then you repeat the cycle?

We do it 31 times. Up and down.

God. Could you not leave it to a pilot or an astronaut who is trained for that kind of endurance?

Astronauts are often on the planes with us, doing physiology experiments. And if you go one step further, you go to the International Space Station (ISS), but there almost all experiments are automated. Scientists make big lists of how to run an experiment on the ISS but often there is a gulf between the astronauts who press our buttons, and us who have designed the experiment.

> *The experiment gets bolted down. We are strapped in and they give us drugs to stop us from getting sick. It has the effect of a lot of gin and tonics. It disengages a part of your brain, so you don't get mixed messages between your hearing and vision.*

I first heard you speak at the UK Space Conference in 2015. The Arena in Liverpool played host to some 1,000 delegates, predominantly white, middle aged men in suits. The crowd was euphoric in anticipation of Tim Peake's going up in Space. Beamed in from training in Kazakhstan he appeared on gigantic video screens while various high-powered Space officials gave boosting speeches to match. It was like a mix between a Beyoncé concert and a megachurch gathering. And in this setting, you went on stage and declared Astronauts to be *merely glorified lab technicians*.

I am friends with many astronauts, so I didn't think I was insulting anyone and it is a fact that we do the conceptualising and they execute our commands.

You demanded room and financial conditions for scientists and bulky experiments on future commercial parabolic flights. You then showed a b/w grainy video of two ice particles colliding, which kind of looks like a conceptual art video from 1975. One could hear a pin drop and I thought, *this woman is mad* and then all

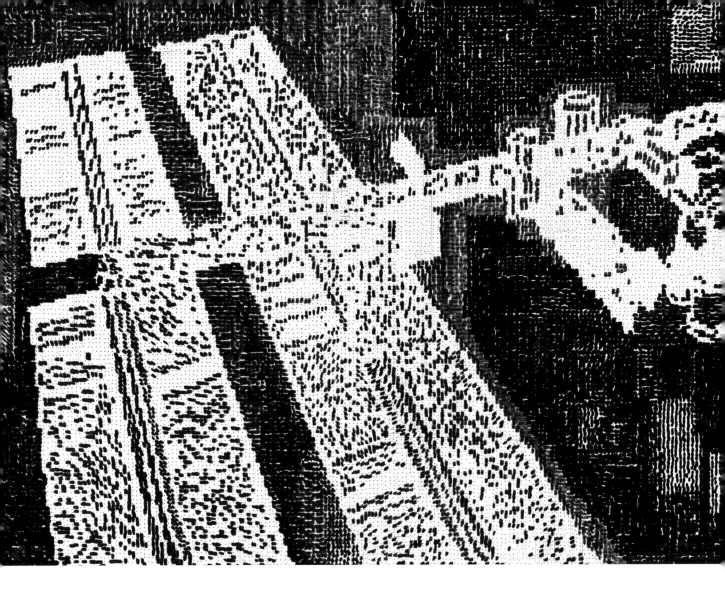

Aleksandra Mir
INTERNATIONAL SPACE STATION
fibre-tipped pen on paper
70x100 cm, 2015–17

these entrepreneurs broke up in applause and lined up to give you their business cards. You definitely won the conference, but at what cost?

The ISS exists for the purpose of science, yet we scientists have rarely been asked on board. Very interestingly, when astronauts with scientific research training are selected, by ESA or NASA, the quality of the scientific data they generate from undertaking experiments on the ISS is outstanding. NASA has flown a few science specialists, and ESA now has one – but the skills sought in current astronauts are not necessarily those a research scientist looks for – astronauts have many other jobs to do too – so it's a compromise. And partly as a result of that talk, I will be taking an experiment on a Virgin Galactic flight next year. Years of hard work is finally paying off.

It is impressive to see you take centre stage as these new economies are forming around you, demanding resources, breaking the rules and challenging consensus in a non-diplomatic way. It was the most radical thing I had seen in ages – and I work in the art world!

Science is very competitive, lots of A-type personalities competing for funding and at the same time, scientists have a lot of doubts and self-questioning. We teach our students here that it is important to have a *scientific opinion*, to be able to argue your point.

It is performative and emotional, like any stage art, which seems risky if your whole practice is built around conveying fact.

People often say that there is no emotion in science. But there is great emotion invested in what we do. When you have an argument about it you become emotional but when you present a fact, you are expected to leave emotion out. I guess I am unusual in that way that I always bring my passion along.

You seized your moment.

Believe me, there are many days when you work hard, you put in hours and hours, it is a very slow burn, nothing works out and sometimes you fall off a cliff edge. In that sense, science is not that very different from art. If you have got a good benefactor, or a grant coming in, you can really see a way forward. Then you can also be riding high and doing really well but see the cliff edge approaching when the money is going

to run out. You have to finish what you are doing but at the same time you have to start preparing so you don't fall off. Or you have to be completely ready to fall off the cliff edge, eat beans for six months and get up again. It was hard at the start of my career and there have been hard patches along the way but luckily at this moment I think I am starting to gain momentum.

To speak with such clarity of mind in a euphoric assembly you need to bring your own urgency.

Sometimes in all the euphoria around astronauts and Space the science gets lost. Sometimes people forget why the ISS is there. It is there because it is a scientific lab. It is there so we can do the kind of scientific experiments we wouldn't be able to do anywhere else. The current generation really need to think about what the impact is on the other end. I have a very luxurious project. My end clients are other scientists, but also inspiring the next generation – education is vital in the modern world – that's another role astronauts do very well.

Science for the sake of science?

Science for the sake of knowledge. Astronomy is very visual, it captures the imagination. And this fits with the Open University idea. We are here to fill a gap in the market which enables people to take themselves from somewhere where they might not even have an O-level in maths, and we take them all the way through a degree in science.

For the longest time, the ISS was simply the domain of engineers and astronauts who built and maintained it and so it is perceived as a predominantly technical project. Has the myth of the heroic astronaut prevented more scientists from going?

The first generation astronauts were male fighter pilots who were willing to take risks, take commands and do what they are told. This makes a lot of sense when you take them to the next level in Space. But then you have a self-perpetuating problem. If you consider that the right person for the job is someone like you, then the next person you pick is going to be someone like you. Since then, the Americans have had a number of mission scientists on the shuttle flights where there were two or three pilot astronauts and two or three science astronauts. India are starting to take that approach. China is not so clear. In Europe, we currently have one out of six with science research backgrounds. But an astronaut is definitely a certain type of person who is able to make a lot of sacrifices. They only get six hours of sleep every night. They are away from their families. Every five minutes they are told what to do. I would love to go up in Space but I get frustrated if I am told what to do in this job!

We teach our students here that it is important to have a scientific opinion, to be able to argue your point.

It is a balance between who can exist in that environment, who can maintain it and who can perform the best possible science.

I think perhaps this will develop. Right now, lots of people both in the science and in the manufacturing community are thinking about options, from sub-orbital planes developed for Space tourism that can be converted to host science experiments, to small cubesats which burn up on re-entry, and reusable unmanned crafts. If we start to automate more experiments or are able to go on more unmanned flights, then this also frees up the astronauts for when we first envisioned them. We didn't really expect to be shoving them in a tin can in lower Earth orbit as lab technicians but we envisioned them as pioneers who went and explored the Universe.

If science is late to the game on board the ISS, then the arts and humanities have yet to be invited. At the moment it still seems hard to justify the purpose of a qualified art project inside a spacecraft. But what is the point of all this endurance if we don't have any great storytellers involved?

Astronauts talk a lot about what they see. How small the Earth is from Space, but also the immense darkness that surrounds you.

Artists and Astronauts both belong to the traditional avant-garde. But just as we don't expect to have Sunday painters perform Spacewalks, why should we be content viewing amateur point-and-shoot photographs, delivered by Astronauts on their social media accounts? How can we continue to watch these world class professionals perform pop covers or run marathons on board the ISS, and basically produce stunts that serve to promote their place in no-longer-very-original missions, only to keep the public's attention? Not only do these acts testify to Astronauts' boredom, but they reveal, as you say, that their potential as pioneers and explorers is unfulfilled.

Astronaut photography has great novelty value. But as a visually literate civilisation that has been making images for at least 40,800 years, perhaps by now we should also start expecting more from the cultural products that are being generated from Space? How would the photographs function if they were also channelled through an intellect specifically preoccupied with image making and art history?

Why not involve people who have as much expertise in the arts as you expect from any other professional involved in this endeavour? Most people will never go, so we could use a poet to directly confront and convey that vast darkness of Space, or ask a physically fit dancer/choreographer to feed medical research from their strong bodies while exploring the aesthetic dimensions of movement in microgravity.

The Humanities are not cost effective, we know this, yet they are central to our civilisation's understanding of itself and the legacy we leave behind. But given how hard you have to fight for science, I wonder if any artist will fight that fight and be granted that opportunity, especially if their strength is to show how vulnerable we are as humans?

So what are you doing next?

The plan for our next experiment is to have it run continuously for four hours, trying to lump together a larger body or particles.

Have you ever done it before?

Nobody has ever done it!

Aleksandra Mir
INTERNATIONAL SPACE STATION
fibre-tipped pen on paper, 70x100 cm, 2015–17

Aleksandra Mir
ISS 04 (pages 14–15)
fibre-tipped pen on synthetic canvas, 300x400 cm, 2015–17

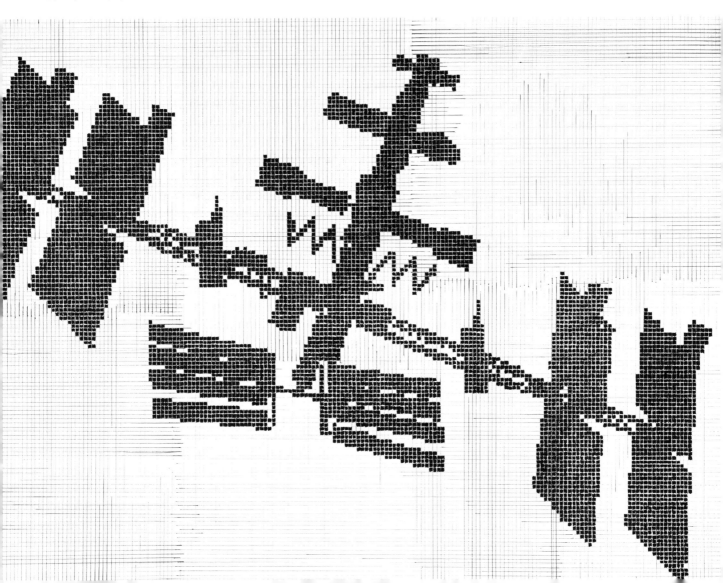

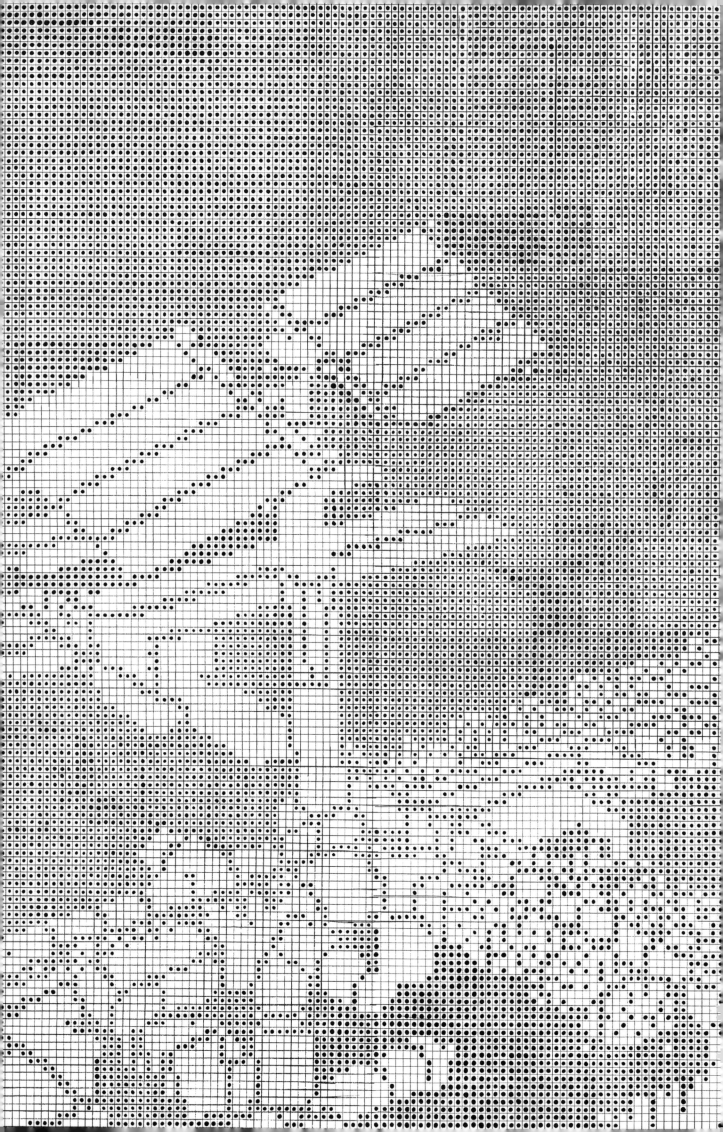

You can't do it without geography

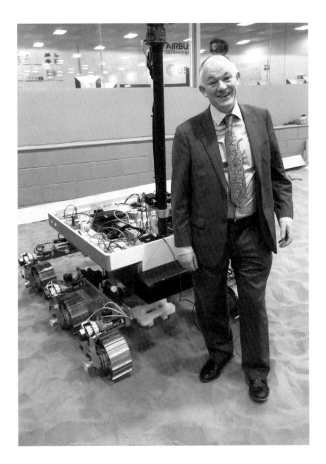

MATTHEW STUTTARD is the Advanced Systems Architect for the UK Space division of Airbus. He is based on the Stevenage site and his previous role there was head of future programmes in Space Science and Planetary Exploration.

Aleksandra Mir
PLUTO – AND FROM HERE YOU LOOK SO SMALL (detail)
fibre-tipped pen on synthetic canvas
200x1000 cm, 2015–17

ALEKSANDRA: The manufacturing of some of the most advanced technologies that you are involved with takes place in gigantic clean rooms behind unassuming red brick facades in an anonymous industrial estate. How do you negotiate the mundane with the extraordinary at work?

MATTHEW: We build all sorts of robotic spacecraft here. From the geostationary telecommunication satellites, which are the main products of this Airbus division, a Mars Rover, the Solar Orbiter to the Space telescope Gaia, which is now mapping a billion stars.

The funny thing is that because I work on Space subjects every day it becomes rather normal and sometimes almost mundane. It can be hard work to come up with new concepts for the next generation of Space missions, but the pressures on the project teams who design and build them are even greater and sometimes enormous. Everything has to be right because things have to work perfectly in Space first time and, in some cases, for decades, through very large temperature cycles, high radiation, a deep vacuum and also survive the intense vibrations and shock loads while getting into Space.

This is all so absorbing that remembering to step back and see what we do with wonder and delight is actually the challenge. This does happen – when missions achieve their objectives we have special events to celebrate them and it is a great feeling.

This factory is a wonderland for an artist. You have got enormous satellite fuel tanks milled out of solid titanium, a whole lab devoted to growing quartz crystals for Space clocks, the Mars yard where the rover can practice driving over a rocky landscape and the Solar Orbiter with its heat shield that will protect the camera lens from melting when it comes closer than ever before to photographing the Sun. These are all mind-boggling forms and features. But what made the strongest impression on me was seeing the building of the satellites by human hands.

Yes indeed, spacecraft are mostly hand built by skilled mechanics, not by machines. We take on apprentices who learn how to put things together. Here in Stevenage

we build very big satellites, we do the metal bashing and plumbing, if I can characterise it very simply. In Guildford we build small satellites and in Portsmouth they make exquisite electronics for our telecom satellites that look like jewellery. These are crafted by people who have trained very deeply in Space-grade soldering. Other Airbus Space factories in Europe do similar high skilled work, but also have different specialities.

I don't actually touch spacecraft. I am not qualified to work in a clean room. If I go into one, for PR purposes, I am not allowed to go past the yellow lines. My job is to think systematically about the future. I work with colleagues to generate bright ideas and shape them to develop new concepts for business.

How do you come up with new ideas?

Many ways, but to give one example: every two years we bring a group of about thirty people from all the home countries together, and we brainstorm in a very structured way. There are many methods to do this, but basically, in order to trigger creativity in people who are usually using the logical part of their brain, we want to release the creative part of their brain. It is called *Ideation Technique* and up to a point, it works and we get those great ideas. It also generates some crazy ideas, and we don't want crazy ideas – though they can also trigger good ones too.

You edit the crazy from the useful?

Exactly, we ideate, then we cluster, then we develop from an idea to a concept and then we develop the concept. At the end of the session, we will have four groups and they will each present as though they are pitching for development money to the chief executive. They go in a day and a half from wild ideas, to having a concrete concept that they can put into a PowerPoint, or stand up and talk about. Selected concepts are matured further and become a flagship mission: a new type of Space camera that can stare at one spot like a CCTV, a debris removal system, a Space tug, aircraft tracking. Space and UAVs (Unmanned Airborne Vehicle), spare launch mass and the Internet of planes were the three topics that I ran workshops on this year. This is just one of the ways that we create the future.

What informs the teams, what are their backgrounds?

Some of the participants are very knowledgeable on specific subjects, but we don't want experts all the time, because they can kill ideas before they are even born. Experts can excel at giving all the reasons why something new is not going to work, just because it is new. They know their stuff *today*, and we are trying to get them to *think about the future*.

How do you avoid killing a good idea?

There are rules. There is a kind of *Thou shalt not lecture* at the start, *You will not kill ideas. You will not judge.*

All ideas are good ideas. Then we say, *Of course later we are going to get serious, and we'll narrow down.* We have collected this year, in those three sessions, thousands of ideas and we have clustered them into a handful of concepts. We'll narrow it down to one or two flagship missions in the end.

Who are the non-experts that you invite to participate?

Well, that is a very good question. We don't invite enough non-experts. What we do is we get people from Space, from commercial aircraft, from our services business. We get the transverse skill groups together. We have had people from finance, people from different parts of the company who understand the company.

They are all from within the industry already?

All within the company, yes. There was a debate on the Internet on planes, *Shall we get somebody from an airline?* The decision was, *No.* That was for a good commercial reason though personally I was in favour of having somebody from an airline. The people in commercial aircraft learned a hell of lot about what you could do with Space systems, and the Space systems people learned a hell of a lot about what the constraints are in commercial aircraft. These workshops are designed to do that kind of meshing, and networking, and building new connections across the company that wouldn't otherwise exist.

You are a geographer originally, would you ever draw on other disciplines, like the social sciences or humanities?

I don't think so. They are probably too far away and we have got to go quickly. It would be too much of a stretch for the experts. However, I have been doing an economic impact analysis for a launcher in the UK over the last few months, and have drawn upon my geographical knowledge that I haven't visited for 37 years. It is very interesting how these things come around. It was incredibly helpful to be able to be a bit more generalist, to take a wider view of the human side of things and feed that into the impact analysis. *What happens if you launch satellites from the UK?* It was a very interesting exercise, and I was using some very rusty skills. I had to polish them up!

You have had a meandering professional journey.

I got into Space by accident. As a geographer I was doing experiments impacting single water drops onto sand targets – very small and short duration events – and never dreamed I would prepare a proposal for a Space mission looking at the evolution of the entire Universe since the Big Bang. I am now accidentally spending a lot of time on launching objects into Space – one can't get further up the Space *value chain* than that. These accidents have all happened because people offered me interesting jobs.

> *It was incredibly helpful to be able to be a bit more generalist, to take a wider view of the human side of things and feed that into the impact analysis.*

You do have a lot going on here.

Airbus is a commercial company. You know us because of that plane. You have flown our product, but what you use far more often than that, is what we do here, Space. Every day you use Space. It is about crop monitoring, improving agriculture, watching the Olympics, mobile satellite communications, broadband and Internet access. You have got Space in your phone, you use it for the weather forecast or when you go on holiday and look at maps or reviews of your hotel. The next step is to have broadband on the move anywhere on the planet through a satellite. That is the next thing that we are working on and this is how I think about the future, not how to live on Mars.

Developing the quality of life on Earth.

And increasing security, hopefully. Secure communications, that is military and civil security stuff, police, fire, ambulance, critical national infrastructure. Or, the government doesn't go down if the communication networks go down, because they have backup systems via satellite. Those things are very important but hidden away. People use Space all the time, but they don't realise it, because it is an invisible technology, up there, out the way, woven into our lives.

We wouldn't know unless Space was switched off?

Boy, we would notice it straightaway! Not only would it affect you personally, but it would affect things like the banking system, because the finance system uses GPS satellites to synchronise transactions. The whole economy runs on the timing of those transactions. Space is deeply threaded into society.

Since when, historically, would you say that Space has been used by everyone? When did we become enmeshed in all of this?

The first satellite communications were in the late '70s, but they were very exclusive, only for governments and global businesses like the oil industry, the media moguls who could afford satellite links. I suppose the general use probably started with satellite TV, if you think about it.

'80s?

Yeah, you could say that is really the starting point. You don't see satellite dishes so much in this part of

the world, but if you go to Istanbul, go up on a high building and look out, it is a sea of satellite dishes. It is an incredibly important technology for countries which have less advanced terrestrial infrastructures. You go to the mountains in India. Dishes absolutely everywhere.

There are many different satellites. What do they all have in common?

A satellite is something that orbits any body. The Moon is our natural satellite that we have been looking at forever. Then later Galileo with his telescope saw the moons of Jupiter. How exciting was that? To actually see, and work out that these satellites were orbiting another planet, and therefore not everything went around the Earth. The church didn't like that, because the Earth was supposed to be the centre of everything. This was all part of the development of science, and the challenging of religious hegemony. Here is Sputnik, the first manmade satellite, launched in 1957.

It is still the most beautiful design.

It was deliberately polished. The designer Sergei Korolev wanted it to look beautiful. He knew it would be in pictures for the rest of time so he insisted on it being shiny.

> *People use Space all the time, but they don't realise it, because it is an invisible technology, up there, out the way, woven into our lives.*

It worked.

Yes it worked, and I saw a flight spare in the Cosmonauts exhibition last year at the Science Museum, absolutely fascinating to see the real thing. It is quite big, bigger than I expected actually. I thought it was a tennis ball size thing, but it was bigger than a football. The inside is absolutely crammed with electronics. It was sending signals out on those four radio antennas.

It also has a very organic quality to it, very likeable.

If you look at Russian designed spacecraft and American designed, and European designed spacecraft, even to do the same job, they all look really different. There isn't necessarily a convergence in design. There is a cultural aspect to the way we design these very functional objects.

The distant Space probes – I made a whole drawing series on this – come in a fantastic array of novel forms and variations. When your design teams

Aleksandra Mir
GAIA
fibre-tipped pen on paper
70x100 cm, 2015–17

start a new project, are they free to imagine any shape or form?

Yes, but there are constraints. The first one is that it has to fit into a launcher. The solution after that needs to provide heat protection from the Sun and that has to have a certain sort of shape. There are literally thousands of requirements and constraints written very formally, *It shall do this, it shall do that and it shall be able to cope with this.* So it can be any shape you like, as long as it meets those requirements. It is unconstrained, but is incredibly constrained at the same time. Some of the new 3D printed parts look very organic indeed.

It is fascinating to look at all these solutions together and over a longer period of time, even just from an aesthetic point of view, the diversity is incredibly pleasing.

Yeah, here is a structure for a radar imaging satellite and here is a structure for an optical imaging satellite, very different. We have turned this one into a standard structure with these drop-down draw-bridges, a really nice generic design that we can more or less repeat. What is wonderful about it is that we can attach all the electronics and equipment onto these panels, and then fold them up and fasten them in. Rather than try to pack

them into a very awkward box. It is called an AstroSat 250 structure. This one over here is very different, because it has got a different job to do.

Gaia looks amazingly different from everything else that came before it.

Gaia is a one-off.

How do you know it is a one-off?

That mission will never be built again. To do that science... Gaia is probably a billion Euros. You only get a mission like that once every 15 years or so and next time round the requirements and the technologies will have changed completely. Gaia is going to do astronomical measurements that will change astronomy forever, as a result of the billion stars that it is going to measure the positions of very, very, very accurately. Gaia carries a gigapixel camera, a thousand million pixels, the biggest imaging detector ever built. The mirrors are bolted onto an optical bench. It is very stable, it cannot

> **Gaia is probably a billion Euros. You only get a mission like that once every 15 years or so and next time the requirements and the technologies will have changed completely.**

move by a nanometre, otherwise the picture will be out of focus. The accuracy is that of somebody on the Moon holding their hand up, and you can measure the difference between the top and the bottom of their thumbnail, from Earth. A billion stars may sound a lot, but it is absolutely tiny. It is just our corner of the galaxy and there are over a billion galaxies. There is another mission that is measuring a billion galaxies, called Euclid, in order to work out whether there is something called dark energy, and dark matter, which is the missing mass.

Where has it gone?

We don't know! The physicists have really let us down. They can only account for 5% of the matter in the Universe and that is just terrible! If anybody said, *I've lost 95% of something,* you would think they were a fool. Well, 95% of the mass they cannot measure, because it is not baryonic. Baryonic matter is the stuff that releases electromagnetic radiation in some way, or is influenced by electromagnetic radiation. So there is all this other matter that somehow we can't sense. You can infer it by looking at the baryonic matter and see how it appears. If you can look at how the galaxies are distributed or how they appear to us when we view them through the dark matter, we can work out how they are being changed by the gravity of dark matter. Euclid's mapping is almost like going for a CT scan, a CT scan of the Universe to try and work out where all the dark matter is. It is hilarious.

I don't quite understand how a satellite can go up and stay in the right place? How does it not just float away?

We have people who do nothing but that maths. When Isaac Newton saw that apple fall… have you ever been to Woolsthorpe? It is a National Trust property not far up the road, a really nice place to visit. I highly recommend it on a summer's day. Isaac Newton was from there, born into a gentleman farming family and he happened to be ferociously intelligent. He observed an apple falling from a tree, this is a very, very famous story. Then he wondered what brought the apple down to Earth, and realised that there was this force, and it was gravity. This got him started on developing his *Principia Mathematica,* a very famous book which set out all of the

physics which governs celestial mechanics, until Einstein came along in 1905 with his theory of relativity, and said, *Well ah, actually Newton was right, but he didn't think of this, this, and this.* Newton was assuming that gravity works instantly and space/time is linear; Einstein worked out that gravity does not act instantaneously, so space/time is curved. In terms of satellites, we only need to consider Newtonian mechanics.

It almost sounds primitive now.

Yes, but it gets very complicated, because there are perturbations, and it is not as simple as in the text books. So we have people who are doing the calculations, and the modelling of how you get a satellite into orbit, and keep it in the right orbit. When you launch a satellite into orbit it is falling to Earth all the time, like throwing a stone, but it never hits the Earth, because it is going so fast the Earth is always out of the way, so it keeps going around.

> **When you launch a satellite into orbit it is falling to Earth all the time but it never hits the ground, because it is going so fast the Earth is always out of the way, so it keeps going around.**

Around and around, but at different heights.

Well yeah, there are different orbits for different purposes. It is a big subject. The geostationary ones are much further out, they are orbiting the Earth once a day above the equator, which is great, because then they stay over the same spot. The Earth observing ones travel from North Pole to South Pole and they are much nearer to the Earth to get a more detailed view of the planet, about 800 kilometres away and they go around much faster, about 14 times a day. This is a model of a geostationary telecommunication satellite, our main product. It is a really big radio transmitter in Space. Our main business is to churn these things out and we build three or four a year. The electronics for it is built in our other factory in Portsmouth, it is all put together and tested in France, and then shipped from there to Kourou in South America to be launched into orbit. At that point we hand it over to the customer.

You only build the hardware but you have nothing to do with how it's managed?

For a few satellites we do also operate them, but mostly we build them for other operating companies

like Inmarsat or SES; SES sells bandwidth to Sky and other satellite TV companies. The operator business is called the *downstream market*, and it is worth billions. We don't make much profit on these, the margins are actually very tight. I am not completely joking. Operations is where most of the money is. *Satcomms* is very commercial, and it is a global business. We have customers all over the world, and we compete directly with international competitors. It is hard-nosed, head-to-head competition. We are trying to beat the competition by improving our technologies and getting the price down. The European Space Agency, and the UK Space Agency, support us to develop new technologies.

These satellites have to be strong enough to endure incredible forces of launch and at the same time agile enough to perform the most minute manoeuvres. How do you balance those requirements against the pressure to compete for contracts?

These days everything is designed to get the weight right down. The cost of launching mass into Space is approximately $20,000 per kilogramme, so bringing the mass down is crucial.

I just worked out how much I would cost.

Well you can work it out, but I am not going to...

A good reason to diet.

You want to make the structure as light as possible, but also strong enough so that the thing can survive the launch. But the structure is not earning you money when you are in Space, right? The bit that earns the money is the electronics and the antennas, and the power system that drives them. So our design engineers' task is to optimise the mass and to ensure that the various parts can stand the g-forces. It is all done by the very smart engineers in here who can focus on a problem like you wouldn't believe, to get it right.

The speed at which this technology moves is intense. There is no way any regular person can follow this and truly understand it all.

Interesting you say that, we have come a very long way in Space, but for launch we are still using the same technology that Wernher von Braun invented in the Second World War to fire V2 rockets at London. There is a very exciting story about how the Russians and the Americans and Brits were all after him, and the Americans got to him first, and took him to the US. He was inserted into their missile launcher programme, which resulted in the massive Saturn V rockets, the biggest rockets that have ever been built until now, that were needed for the Apollo programme. We are still, for launching things into Space, using a huge explosion that is very carefully controlled. It is a pretty crude process, and that hasn't changed, but lots of

> **We are still, for launching things into Space, using a huge explosion that is very carefully controlled.**

other things have. Electronics, the efficiency of solar arrays, are continuously refined. Now our satellites are changing dramatically, and Space is very exciting at the moment in terms of what it can do for humans on Earth. This is a new project we are building at the moment. These little bees are low Earth orbit satellites for an American company called *OneWeb*. It is a wholly new idea of building a dense web of communication satellites near to Earth, only 1,200 kilometres above, and 700 of them are needed.

How many can you make?

We will eventually be knocking them out at up to four a day.

So from four a year, to *four a day*.

These are no longer hand-built but require more automation. They are small, only 150kg compared to the big geo comsats that can be up to 10 tonnes. Both types are needed.

What is the timeframe on these?

OneWeb will come into operation in the 2019–2020 timeframe. It will provide global broadband Internet access. Not to your mobile phone, but to a smallish base station. It won't be portable, it needs an antenna which is quite small but you could not carry it. It may be put in aeroplanes. So I am afraid the peace of an aeroplane will no longer be there, you'll have annoying people Skyping on their phones.

The success of this web eventually depends on what is on the ground, the receivers, and that is subject to national interests – geopolitics.

Oh yes. The ground stations can't all be in America. They have to be distributed around the world in order to get the coverage. There will be over 50 ground receiving stations and deals that have to be done all around the world to get those ground stations in place to make it work. You can't do it without Geography, that is absolutely true. Really good point.

Emma Ridgway and Sara Lowes from Modern Art Oxford visit with Matthew Stuttard at the Mars Yard
Airbus Defence and Space, Stevenage

Aleksandra Mir
PROBES (pages 24–25)
fibre-tipped pen on paper
70x100 cm each, 2015–17

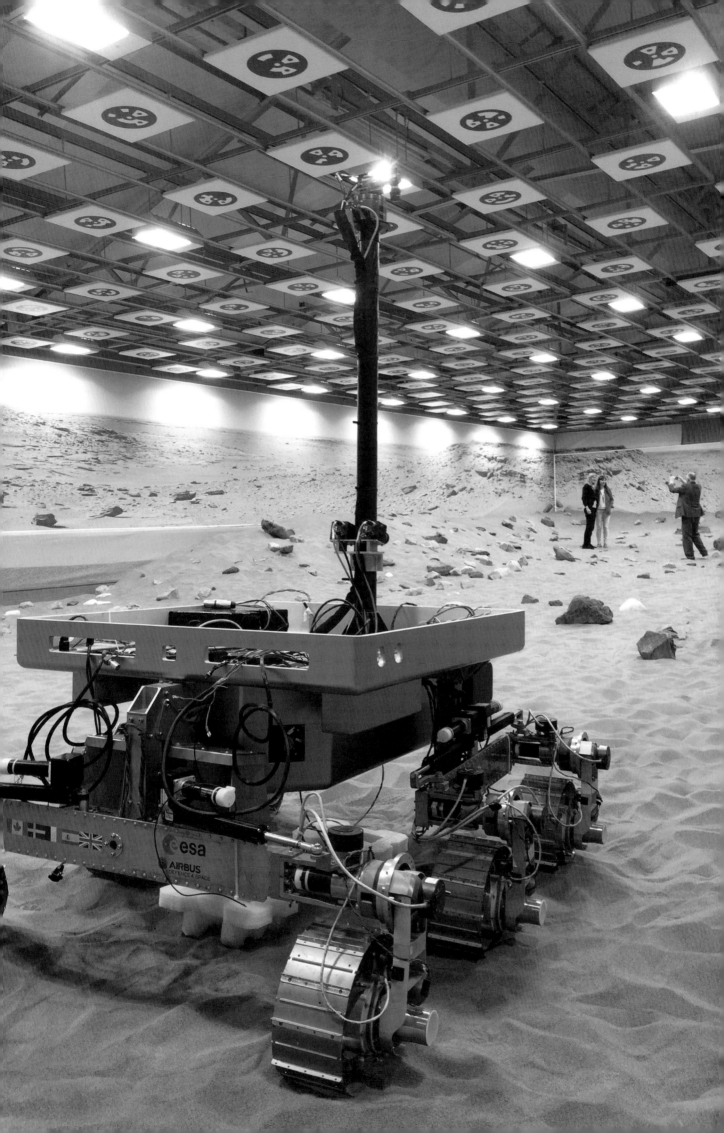

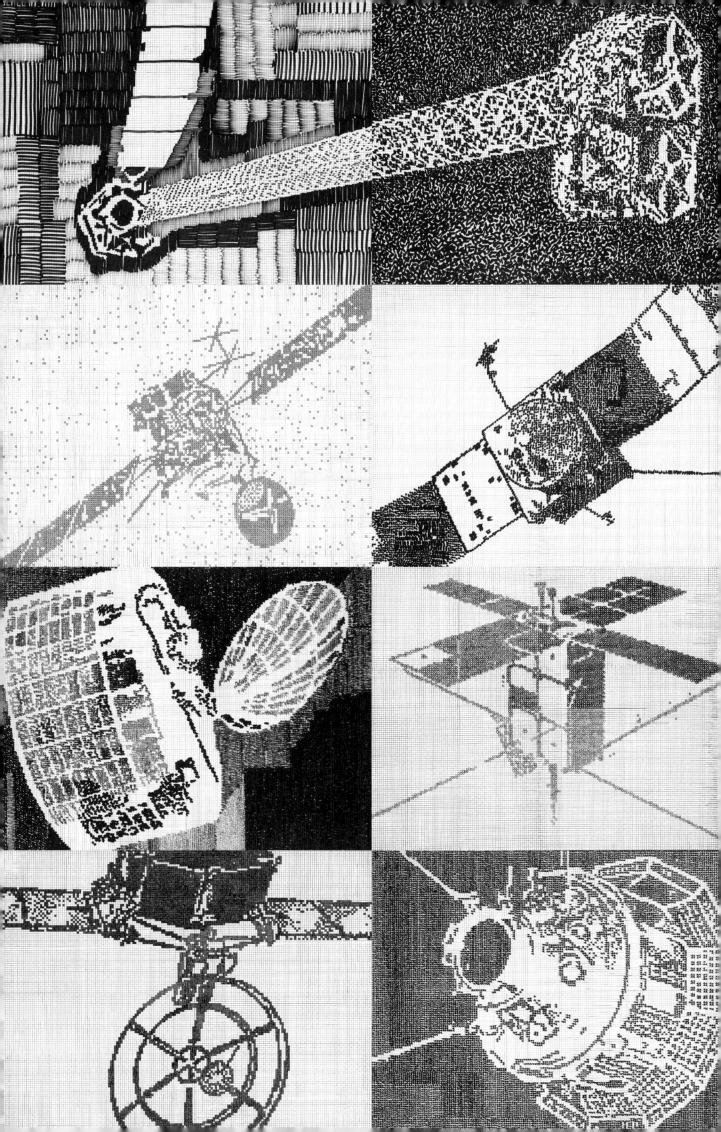

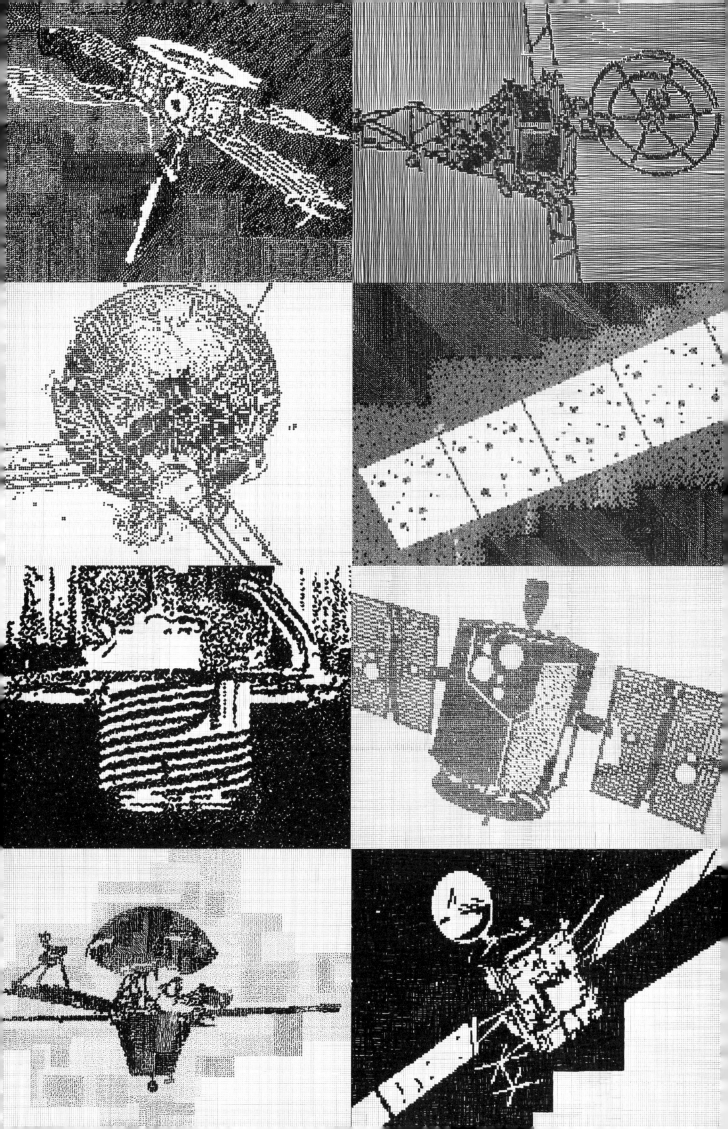

You can't exactly predict where you will end up

SANJEEV GUPTA is Professor of Earth Science at the Department of Earth Science and Engineering, Imperial College, London. He is also a science team member and Long Term Planner on the NASA Mars Science Laboratory Curiosity rover mission, which keeps him awake at night.

ALEKSANDRA: I first heard you speak at a BBC live audience radio event. You were in a panel surrounded by loudmouthed media pundits bragging about their sci-fi credentials. I thought it was an unworthy context for you, since you were the one person actually working in Space. You talked about being a geologist and about exploration, which is where it starts to become interesting for me as well.

SANJEEV: Mm-hmm. I have never really paid much attention to sci-fi. I got into planetary exploration almost accidentally in that I like exploration. My interest is in landscapes and I did geology because I liked exploring. I have always wanted to go camping and travelling. Actually the reason I did geology as a career was to travel.

The Earth.

I wanted to go to Tibet and Himalaya and places. I avidly read books about exploration when I was a child and dreamt of climbing the Himalayas, this sort of thing. I had to rebel against my parents who wanted me to be a doctor. My father was a biologist, so I used to tag along when he would take field trips for school children, but I was not interested in live things. I was interested in dead things – fossils.

Field work is a lifestyle. You have to want to be out there and embody the environment you walk into. You have to take certain risks. Is it a sense of adventure that brings you there, or is it the inquiry?

It's quite interesting actually. I wonder... it is quite peculiar that I should be interested in that because I grew up in an Indian family who didn't do that sort of thing. My hometown is in the foothills of the Himalayas but people there don't normally go off travelling in the mountains. It is not something my parents did, so it is actually something that came out of reading.

You had to get into the mindset of an explorer, not just make an intellectual decision.

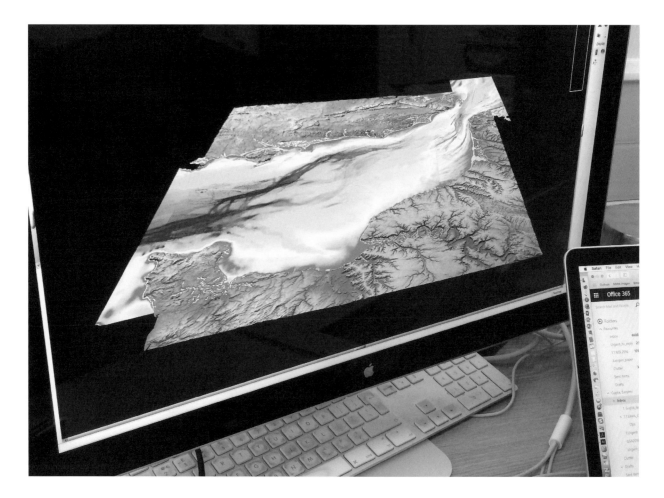

View from Sanjeev Gupta's computer screen of the
seafloor physiography beneath the English Channel
Imperial College London, 2017

The decision to do it may not have been intellectual, but it becomes intellectual when you are trying to understand the subject, when you are trying to explain nature, when you say, *This is why*. I am trying to understand how it came to be basically, so I look at the landscape and at the rocks and try and reconstruct the ancient environment that they were formed in. Basically I am trying to reconstruct that past.

You specialise in deserts, exposed rock.

I like warm places rather than cold places and I mainly work in desert areas where you can see the rocks beautifully and you can map them easily.

How do you read the landscape when you go into a desert?

You read at multiple levels. Firstly, you can look at a desert landscape and you read the geomorphology, how the topography and the landscape were shaped by recent processes, what makes it a desert. Then the rocks may actually be ancient environments. For example, when I worked in New Mexico I looked at rocks that were deposited 90 million years ago. They were actually deposited in a watery environment but are now exposed in the desert. You can read that signature of an ancient ocean, a seaway, in the rocks. There are all these clues in the rocks that tell you about the environment.

And then do you go deeper into it?

You break it down and look at the grains under a microscope. You can do a chemical analysis of the rocks. One of the things I do, for example, is I try and work out where the rocks have been eroded from and then transported and deposited, and so they were originally fed by rivers and the rivers were derived from mountains. You can read the geochemical signature of the rocks to say where they came from. We call this *Provenance*.

Provenance **is used for the authentication of artwork too. It can be useful if you want to crack a forgery.**

Or if you are a conscientious eater and you want to know the provenance of your meat, which farm did it come from, or your coffee or whatever. We do the same for the rocks. We basically fingerprint a rock to try and work out its source. It is quite an important technique.

You have also studied the landscape underneath the English Channel. How do you get down there?

We used sonar, sending a sound wave from an instrument, which bounces back off the seabed. Because

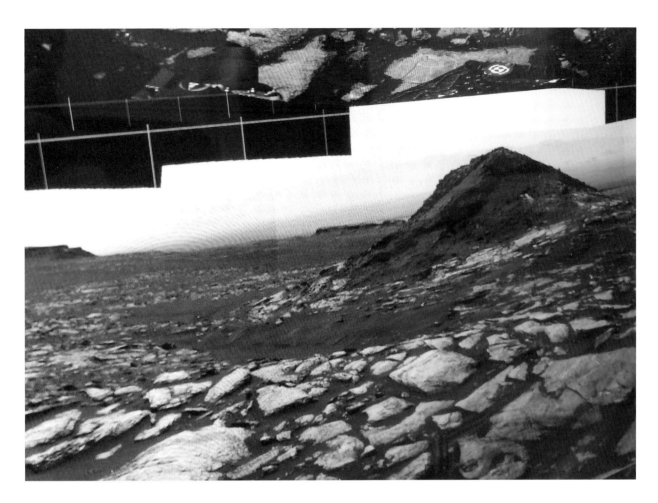

Navigation Camera view of landscape in Gale Crater, Mars as imaged by NASA's Mars Science Laboratory Curiosity rover
Imperial College London, 2017

we know the velocity and the speed of sound in water, we can map the depth of the sea floor. There had been previous maps of the English Channel, but this is the first map at high resolution where you can actually see detailed features on the sea floor. Would you like to see pictures? I will show you pictures that very few people have seen before.

I would love to see them.

Dover is here. Brighton is somewhere along here. Southampton is here, and Calais is here. You can see the blues are deep. Water depths are around 60 or 70 metres. Yellows are about minus 25. The reds are minus 10 metres. You can see this major valley coming through.

And what does that tell you?

This data actually tells us that the landforms here are typical of what we see in other places that have been formed by large scale floods. Huge floods when lakes have collapsed basically. This is going to be our *Brexit* paper. We basically show how the Dover Straits was formed. You see this ridge? It continues all the way to France.

> *I look at the landscape and at the rocks and try and reconstruct the ancient environment that they were formed in. Basically I am trying to reconstruct that past.*

It was one and the same landmass with the rest of Europe. Not a separate island.

What happened is that at the peak of glaciation there was a lake in front of the ice sheets, and that spilled over and broke the rock barrier at the Dover Strait in a catastrophic way.

How appropriate.

It's extremely appropriate. I suspect it will get a bit of interest in April when this comes out. We have worked on it since 2008.

What an amazing study. One hop from the bottom of the sea though, you got picked up to study something completely different in the sky.

The way Mars happened was that when we got the data for the Channel I didn't understand what this data meant. These beautiful island-like features in the seabed here, I didn't know how to interpret them, and then I came across a paper at random in the library with an image from Mars that looked exactly like that. This led me into a paper chase of landforms carved by floods. Then I found a whole literature which shows how people have interpreted these valleys on Mars as being created by large floods.

You learned from Mars exploration what these islands in the sand were?

The Mars images had been interpreted based on Earth examples, but I didn't know about the Earth examples. It was this random sequence of exploration.

Through the literature.

Through the literature that led me on to it. We would have found it eventually, but if it hadn't been for that random finding of that imaging it would have taken much longer.

So how did you then get on the Mars team?

I started doing some work on Mars data sets. We had a visitor here and he said, *That is really interesting what you are doing. You know that's one of the landing sites for the next rover, MSL?* I said, *What is MSL?* He said, *Oh okay. You need to go to the landing site workshop for MSL* which is the Mars Science Laboratory mission. I went to the landing site workshop and talked about these features and they thought that I had the skills and the competence from my terrestrial experience to look at and understand what features of Mars might be like. This was in 2011. It is funny as next week I am going to California for the landing site workshop for the next NASA rover.

Everything just clicked.

Sort of. I am not sure it looked like that exactly, but yes.

You talk about Earth analogues. Is Earth really that easily transferrable. Is Mars just an ancient version of Earth? Are they out of sync twins where one civilisation collapses and get studied by the other?

The features we see on Mars look very similar to what we see on Earth. Otherwise we wouldn't be able to interpret it. I recently gave a talk in Belgium, and one of Belgium's most famous novelists was in the audience. She asked me, *Weren't you disappointed that it was so earth-like?* I said, *No, because if it wasn't Earth-like it would be much more difficult to interpret.* That's how I got on the team. I can interpret Mars based on my field experience from Earth.

> ## *The features we see on Mars look very similar to what we see on Earth. Otherwise we wouldn't be able to interpret it.*

Brilliant. I bet she is putting that in her next novel. So it is still in a way field work that you do, although remotely. Is it still considered field work? Is it still the same experience?

No, it is not the same experience. It is completely different because you are looking at images on a computer screen.

So what is your daily procedure? Every day you wake up and you have images in front of you that no human has ever seen before.

We have a website for the team. This is for the camera team that I am a member of, and the photos get automatically processed. Here is an image that was taken by the rover on Monday. On Wednesday we used this image to help us plan our drive yesterday. We did some activities and then we drove…

I love when you say you drove. You are actually steering this thing?

No, no, no. No, the engineer drives it. I go nowhere near it. They send the rover a set of computer commands on where to drive to.

But you are giving the instructions? You are on the team who says where you want to go and look, *Go left, right, forward.*

Yes, so here are the rocks that we analyse. We are actually going to be doing an experiment where we look at the modern sand dunes in this desert, so we want to get closer. We are going to drive over here to do observations of these dune sands.

You can pick stuff up.

The rover has an arm and at the end of the arm there is a hand lens camera, so we can get a close-up look at the sand grains. There is also a geochemistry instrument. We will apply that to the sand to measure the chemistry of the sand grains. We also want to know how the sand is moving in the ripples, so over the past three days we have been doing repeat imaging of the same patch of sand to see how that sand is moving.

You are able to monitor real time changes now.

Yes.

The images, how long is it between when they are taken and when you see them?

It depends on the satellite passes. We commanded the rover to take some images yesterday. They are probably being taken at this very moment because it is currently daytime on Mars.

The rover can only work during daytime.

We recharge the rover at night. Pictures will be taken around now and then they will be sent back, first to the orbiters and then from the orbiters to Earth. We should receive them tomorrow. At the moment there is a bit of a gap because a Mars day is longer than an Earth day. So it means that sometimes we are in sync with Mars and sometimes we are out of sync. This week we are out of sync. Next week we are in sync, so next week when we get the data back we can work on a daily cycle, but at the moment we work on a two-day cycle. We can't do anything until we receive the data because we don't know where we have driven to. You can't exactly predict where you will end up.

> *A Mars day is longer than an Earth day. So it means that sometimes we are in sync with Mars and sometimes we are out of sync.*

It is call and response, and while you wait, the rover stands still waiting for your next command? How does this affect your life here?

Talk to my wife. She hates it. Actually, I think more because NASA is based in California, so we are working in the California timeline. Planning starts usually around 4:00 PM our time, 8:00 AM California time. Yesterday I was on shift and I worked until midnight. It has become more efficient because people are much faster at doing things. Early on when it used to take much longer to do things you would work until three or four in the morning.

But you are not actually on Mars time.

No, we did that for the first three months, but we only do that for a short time because it is awful. It is not just Mars time. It is partly dependent on when we get the satellite passes for data down, so what would happen is that every day you would be working an hour later, and then it suddenly would step back two hours and then go forward.

It sounds like torture.

The three months were like being permanently jet lagged. It was terrible.

Was it necessary?

Yes, because we needed to be able to work efficiently and swiftly in the first few months of the mission.

What is your motivation at this point, to get up every morning and to see the new batch of images of Mars? Is it to find the answer to the question you were hired to answer, or is it still an exploratory curiosity to see what is behind the next hill, that no human has ever seen?

How can I answer that? Yes that is part of my motivation but I also find many other things interesting. I am actually interested in something else at the moment. I am actually doing archaeology right now.

Okay, so let's talk about that then.

Essentially, I like to solve problems associated with ancient environments. On Mars, what I am searching for are the ancient environments where life might have formed and been preserved. That is the goal for Mars exploration, but for the other current project I am doing I am look at early civilisations. I work on the Indus Valley civilisation, which is a Bronze age civilisation in northwest India and Pakistan, equivalent in time to the Egyptian and the Mesopotamian civilisations. These were the first civilisations that had urban developments.

People went from living in villages to suddenly living in small towns and cities. So, this is the development of urbanisation. We are exploring how settlement patterns are governed by river migrations. We look at river environments and lake environments, which is exactly what I explore on Mars but as I look at these rocks or sediments I relate them to the archaeology, so it is another form of exploration. I like finding problems where I can apply my skills. The set of skills or tools I have are the same. I just apply them to different questions.

It seems to me that the more we learn about what is out there or in the past it always brings us back to how to live *here and now*. You have for example talked to me about naming conventions. You are in a way free to name these novel geological features on Mars any way you like. But you end up naming them after existing features on Earth so there is an echo between them.

There is an international astronomical commission on naming things, but it can't deal with the number of names for every little rock we encounter. So we had to find an informal way of naming things between us. Numbers don't work because they easily get confused and they are boring, so we had to find some sort of convention. We generally name things

after towns or places with a geological link on Earth because it is what we know and that means we can go on different continents.

How big is the community that shares these informal names at the moment?

It is a science team of 400 people. I am not in charge of naming, but I am the gatekeeper of names.

The gatekeeper of names. **Wonderful.**

I am one of what is called the *long term strategic planners* for the mission, so there are about six of us and we rotate. I was on shift yesterday. It gets exhausting because we work every day. I report our location, where we are, the view we had. Then I help evaluate and give guidance to the mission goals. I lay out what the rover is going to be doing each day for the next week: what experiments, what observations it is going to be doing. So yesterday we selected some rocks that we are now going to analyse, and to do that, we have to give them a target name.

You make up the names as you come across new rocks? Where are you now?

These are from... This is Northwest... Northeast USA.

So in a way you are travelling the US, albeit in parallel world?

No, not like that. Before we landed, we set up quads on the map so that we could start doing geological mapping based on the orbital images because we didn't know exactly where the rover was going to land, and then we gave the quads names based on locations on Earth. One is in South Africa, and so all the names in that quad are based on geological names in South Africa and Namibia. Then we moved into Bar Harbour, which is in Maine.

> ***I am in not in charge of naming, but I am the gatekeeper of names.***

South Africa is a neighbour of Maine on Mars. I like the mash-up. I want to finish with a picture of you. Do you have any rocks here at the Royal School of Mines you could hold up?

I have some rocks under my table.

Where is this one from?

Not from Mars. South Wales. Where I am going on holiday this April.

What are you going to do when you actually get a rock from Mars? Would you be able to handle it?

No.

Never?

I think it would go into quarantine in a major way. You don't know what it is going to be bringing back. They will probably have robots extracting it and analysing it. I don't think anybody would be allowed to touch it.

Work in Progress
Aleksandra Mir Studio

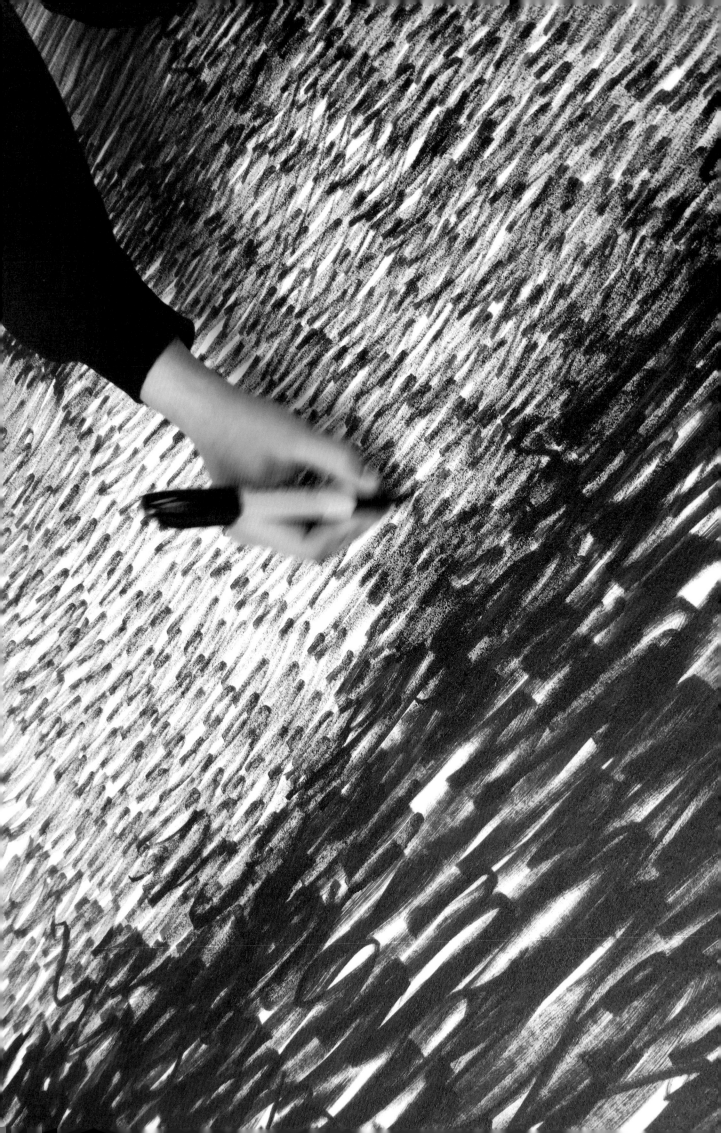

Stare into the void

MAREK KUKULA is an astronomer and science communicator. After a career as a researcher studying distant galaxies and quasars he is now the Public Astronomer at the Royal Observatory Greenwich, where he writes, lectures and curates exhibitions on all aspects of astronomy and Space science.

ALEKSANDRA: This building at the Greenwich Observatory used to be a major photo studio.

MAREK: It was constructed in the 1890s to hold photographic equipment, developing studios, plate storage facilities and archives for photographic materials. There was a telescope, and on the back of it were cameras. Early photography owes a huge debt to 19th century astronomers, in particular Sir John Herschel. Herschel was an excellent draughtsman – we have drawings of his of things he observed through the telescope – but he also recognised the potential of photography as a new scientific tool. He got very involved with developing new photographic techniques and technology and is the person who coined the English word *photography*, from the Greek *drawing with light*. He comes up with terms like *positive* and *negative* to describe the photographic developing process and is the first to use the term *snapshot*. These linguistic elements that we use to describe photography come from an astronomer, who was also a pioneer of photography.

How did he bridge over from drawing his observations to photographing them?

At first photography was not necessarily very useful to astronomers because if you think about very early photography, the two things that you needed were very bright lights and things that stayed really still for a long time. The two things that you don't have in the night sky are bright lights...

...and nothing stands still.

Because the Earth is turning, so everything in the sky appears to move all the time. They needed to develop plates that could detect light during shorter exposures, but also, they needed camera equipment that could track objects in the sky very smoothly, without wobbling over a period of several minutes or even hours. That starts to happen in the middle of the 19th century and it revolutionises astronomy because you no longer have to describe what you have seen through the telescope. You can just record the light.

And go beyond what the eye can see.

In the late 19th century they start getting discoveries where the camera and the glass plate and photographic emulsion are revealing things that the human eye cannot see. It is only when they put the camera against the telescope and take a long exposure that something astonishing reveals itself. Moving into the 20th century, photography really starts to prove its worth. They can now enlarge the photograph to see more detail.

The blow-up.

Today everybody photographs the Horsehead Nebula, this iconic astronomical object that looks a bit like a horse's head. It was first detected photographically by Williamina Fleming at Harvard Observatory in 1888. She didn't see it through the telescope because even through a telescope, it was too faint for the human eye. She looked at one of the plates and saw something unique and unusual. The photographic plate revealed it in all of its glory.

Photography coincided with this period of the separation between art and science. Which side of truth was it on?

There was a really interesting early debate about what photography was, where on the arts side, people were saying, *You can't do art with photography because it is just mechanical reproduction and therefore the human element is removed.* On the scientific side however, there's a worry that it isn't just mechanical reproduction, that it doesn't just show an unbiased view of what's there, that there is a human element. So the concern is from the two sides, both of them want to use photography or are curious about photography but the artists worry that It is *just mechanical* and the scientists worry that it is *not mechanical enough.*

And where did this debate land?

Of course now we accept that photography is a very powerful scientific tool, but we still have discussions like, *When you see a Hubble image of a galaxy or nebula, is that what it really looks like?*

> *Both of them are curious about photography but the artists worry that it is just mechanical and the scientists worry that it is not mechanical enough.*

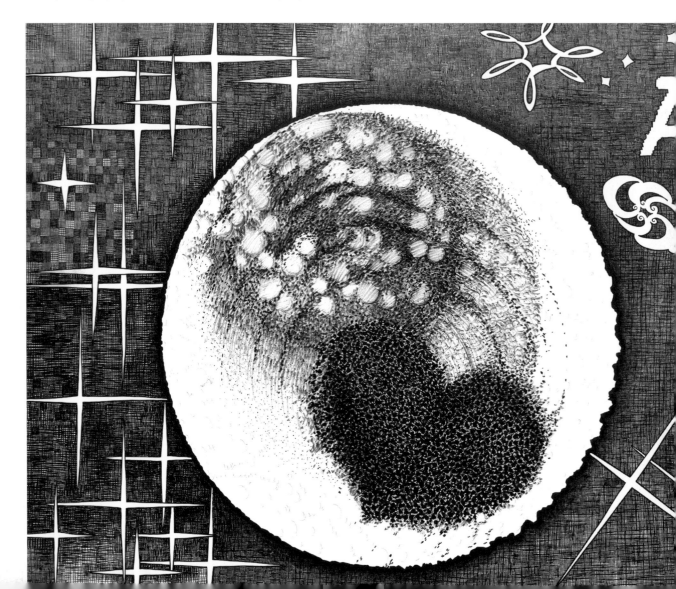

They go and take photographs of an eclipse of the Sun in order to test Einstein's General Theory of Relativity, which is a new, very weird theory.

Everyone asks that question.

Of course, but what do you mean by, *Is that what it really looks like?* It is what Hubble sees, but it is not what you can see.

Because if you could see it, why would you need a telescope in the first place? So it needs to be interpreted for you, and skilled humans do that in a way they think is meaningful. You can debate how they do that, but it is clear that the telescope or the camera will bring their own set of conditions.

And we're also absolutely comfortable with the idea that artists will use photography. It is an established art form today and we don't have a problem with it, but in the 19th century, this was a huge discussion on both sides and people were very anxious about it and it was quite heated.

What happens next?

In 1919 there is a photographic expedition sent out from the observatory here in Greenwich. It is organised by Arthur Eddington, a very clever physicist at Cambridge University. They go and take photographs of an eclipse of the Sun in order to test Einstein's *General Theory of Relativity*, which is a new, very weird theory. It says that space and time are warped and stretched and distorted by the presence of matter so a very massive object like the Sun will warp the space around it. So they go off to view this eclipse, which is only visible from Brazil and West Africa and they take photographs of the Sun during the eclipse where the sky goes dark and you can see the stars. They then compare the positions of the stars on the photograph with their normal positions from star charts and they see that the stars' positions appear to have changed by exactly the amount that Einstein has predicted. Space and time can be stretched and distorted. Distances can be altered. The passage of time can be speeded up or slowed down, weird things, and a photograph captures this.

It captured one secret and opened up another. It is this endless cat and mouse game, the more we know about one thing, the less we know about the things beyond what was just revealed.

In the 1920s, Edwin Hubble took photographs of the Andromeda Nebula and realised that it was not an

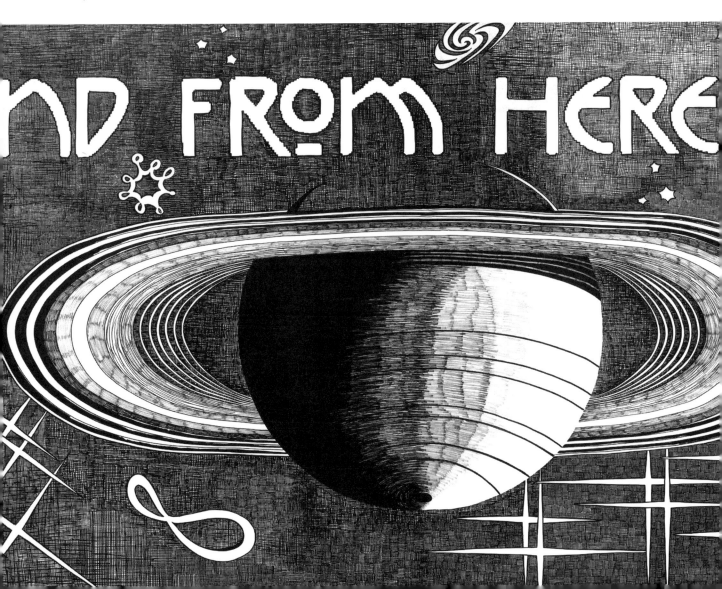

object in our own Milky Way galaxy, but another separate galaxy beyond ours and so suddenly, with that one photograph, the Universe becomes millions of times bigger than people had supposed it was. Again, a photo changing the way we think about the Universe. It is a really powerful technology and these are really profound philosophical ideas.

We are now in Modern times.

People talk about the Cubists and their relationship with things like quantum mechanics and general relativity, these two big theories of the early 20th century that say that fundamentally, the way the Universe works is really strange. Our ideas of geometry and the way the world is structured are an illusion, but it works both ways. There's a lovely story in Arthur Miller's 2014 book *Colliding Worlds* about Paul Dirac, the physicist who is grappling in the 1920s with this idea that comes from quantum mechanics – that subatomic particles, the

> ## Fundamentally, our brains are not equipped to visualise some of the nature of the reality of the world that we live in.

building blocks of matter, the stuff that we're all made of, that they actually have the properties of particles but also the properties of waves. How can something be a particle and a wave at the same time? He reads about an exhibition of Cubist paintings, and thinks, *Well, if Picasso can show you two sides of the lady's head at the same time, then maybe an electron can be a particle and a wave at the same time.* Maybe this is okay, so these ideas are feeding off each other.

Art is not necessarily proof of anything. Art only suggests a possibility. If you are stuck on a problem, perhaps you can live easier with yourself if you accept that there are other possibilities, even those you don't understand.

I think it is an acceptance that perhaps fundamentally, our brains are not equipped to visualise some of the nature of the reality of the world that we live in, that actually, our perception of the world around us and our expectations about the way the world behaves, perhaps you can describe it as an illusion or at least an approximation, which breaks down on very large cosmic scales and breaks down on very small subatomic scales.

Artists talk about reaching beyond the limits of perception, but myself and my peers, we don't take it as far as saying, *We want to understand the true nature of the Universe.* We are preoccupied with the

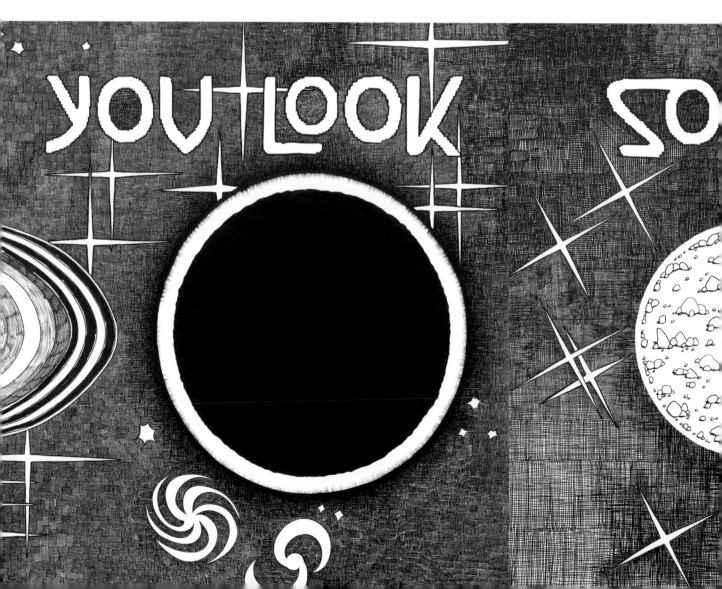

present day, our art is urgent and reactive to what is going on, which is both a curse and a blessing. I interviewed Irena Sedlecká, an 80-year-old artist. She has an incredibly dramatic life story that is also the story of the 20th century. She started as a Socialist Realist superstar, dropped out and eventually got the commission late in life to do a statue of Freddie Mercury. It really is a masterpiece, anachronistic and outdated, merging Classicism, Socialist Realism and Glam Rock. So her life's work is proof that art can transcend ideologies, upheavals and time periods in which they are made. Her dedication was absolute. She took years to prepare her studies, which is not an economically viable way to work anymore. The purpose of her spending time, though, was to pierce through the layers of her own perception to produce something very distorted and true at the same time. When I asked her what she thought she had achieved in her seven decades of practice, she said enigmatically, *I think that, perhaps, I touched it.*

That's such a great story. There are fashions and movements in science too. It is a human, cultural activity after all. And sometimes the big ideas, the big discoveries, take decades to mature and come to fruition, so in the process they are passed through the prism of many different individuals, many scientific styles and paradigms that all leave their mark. What starts to happen in science in those early days of modern

life did play into a lot of other ideas that were going on in art at the same time, where people were questioning our biological sensory perception of the world around us, but they are also questioning the way our societies and our cultures condition us to think.

But by now these structures and differences have been thoroughly explored. I think by now we more or less know what culture is, how we make it and how it makes us.

I think right now there is a need for people to talk across cultural divides, whether that is a disciplinary culture or whether it is actually a national or religious culture. It has never been more important.

I had this idea that I could reinvent the Hubble aesthetic. It has been running now for 20 years straight and could use aesthetic scrutiny. I had a very clear vision of how to do that but I didn't know anything about data, so I reached out for an astronomer to collaborate with and you introduced me to an old colleague from the Hubble Heritage Project, Astronomer Jayanne English. The challenge was, could we by working together come up with something entirely fresh that would satisfy both our agendas. It was a real struggle but we eventually proved that one could use b/w patterns of various density to convey the contrast between various elements. The densities indicate various properties,

Aleksandra Mir
PLUTO – AND FROM HERE YOU LOOK SO SMALL
fibre-tipped pen on synthetic canvas
200x1000 cm
2015–17

one kind of gas is cooler, another is hotter, and that then shows how temperature changes with location in the nebula, for example. But it doesn't have to be red or blue. You don't need colour or that sleazy retouched aesthetic. You don't have to hide away the process. My hand-made drawing was completely raw and she said it was worthy of being described in a scientific paper!

Great. I love that you call it a sleazy aesthetic. As scientists we're trained to really focus on the functionality of how the image is presented. Does it convey the essential information clearly? I love that it could be functionally effective but still sleazy. At the Royal Observatory we have our astrophotography competition, *Insight Astronomy Photographer of the Year*, where every year these amazingly skilled amateur astronomers use backyard telescopes and commercially available digital cameras to take really superb images. They put in hours of observing, hours of processing on the laptop and they're all steeped in the Hubble aesthetic. They strive to make their images look as Hubble-like as possible, and they really achieve it. But I'd love to encourage them to experiment, to break out of that mould and do something that the professional astronomers don't, or wont. Show us the Universe in a new way. Maybe even change the way the professionals present their data. Sometimes that outside status gives you the freedom to innovate.

Amateur practice is plagued by aspiration, trying hard to do *good*, but Avant Garde is about questioning why something is deemed good in the first place. When you first came to my studio I was struggling with drawing a star shape. It seems pretty damn obvious, but when you draw a star with awareness, several problems present themselves, *How many spikes, how long spikes, and why spikes in the first place?*

Yeah, that little blob of light with spikes or rays coming out of it is how we all think a star should look. But stars don't actually have spikes. The star *shape* is just a distortion imposed on the star's light by the atmosphere, the telescope and your eye in the last split second of a journey that may have taken hundreds or even thousands of years. This isn't the actual shape of a star, it's a distortion imposed on the starlight by the refraction of the air and the optics of your eye and in the telescope. It involves the neuroscience of visual perception in the eye and brain, photography and the culture of visual representation in art and science. How we perceive and represent the world and the way we sometimes come to unquestioningly take the representation for the real thing.

Kids and cartoonists still draw stars that way.

They are all over the vault of the Scrovegni Chapel in Padua! It is how stars were depicted in art for a very long time, but then after the 19th century something changed. We started to see stars depicted as little round

> *I love that you call it a sleazy aesthetic. As scientists we're trained to really focus on the functionality of how the image is presented.*

blobs of light, with this very pronounced cross-shaped pattern of four sharp rays emerging from it, sometimes also with a ring of light around the central blob.

Those are popular on Christmas cards and in sci-fi movies, where they seem real.

The rays are called diffraction spikes and they are caused by the way light passing through a reflecting telescope is distorted around the physical structure of the telescope – the struts that support the mirrors inside the scope and so on. So you won't see a star with diffraction spikes like this with your naked eye, only through a particular type of telescope. But the main reason that we're so familiar with this way of seeing a star is photography. The diffraction spikes are relatively faint but in the long exposure of a photograph they come through very clearly. So it's only when photography becomes a widely used and widely disseminated tool of astronomy in the late 19th century that this way of seeing and representing stars becomes familiar.

I tried to avoid all associations with known star shapes by experimenting with atypical shapes, but eventually resorted to just making lots of dots. It can be a depiction of the Milky Way, but it can also be a snowfall, or just a study of dots. The meaning starts breaking up.

Every telescope will impose its own unique diffraction pattern on the image of a star and as a researcher I spent around a decade trying to understand the detailed structure of the Hubble's diffraction pattern so that it could be removed from my images using computer software. The idea was to try to return the image to as close as possible to what these distant stars and galaxies actually look like. So, like you, I was very focused on this *shape of a star*, very aware that this isn't the star itself, but a distorted image. Both astronomers and artists understand that the act of looking imposes its own imprint onto the image of what we're looking at, that what we see isn't just what's out there but is influenced by the way we're looking.

I then worked on grids that are meant to support the making of flat digital representations, a mechanical approach but hand drawn, full of flaws and painstakingly slow. I tell my assistant that we are *human robots*.

Your grid drawing resembles the close up image of Mars taken by the Mariner 4 spacecraft as it

So somebody goes out to the local art supply store and buys a box of artist's pastels. This is the first digital image of Mars and it is a drawing, not a photograph.

approached the Red Planet. It is a digital image but it was made with pastel crayons. Basically, it is a photograph broken up into pixels, into little units, that were drawn in with crayons.

NASA used crayons?

NASA catalogues and makes available all their images. Most are photographs, but this one is actually weird because it is a drawing, made by scientists.

It is beautiful.

It is, and it's a really cool story. They had never seen Mars close up before, only blurrily through a telescope. Mariner 4 was the first probe that captured it. Onboard was a very early version of a digital camera. This was in 1965, way, way, before the modern era of digital cameras. The image was broken up into a grid of pixels. Each pixel a number that converted back into brightness and recorded onto a tape recorder on the spacecraft.

The scientists were getting a ticker tape stream of numbers. As they got to the end of a row of pixels, they tore it off, laid it out and put the next row underneath. Playing and beaming back the numbers one by one to Earth was agonisingly slow. They had this primitive '60s computer to convert the numbers into a digital image, but it would take the computer time to crunch through them and produce the image. It was a limiting factor.

They were too excited to wait.

So somebody goes out to the local art supply store and buys a box of artist's pastels. They come back, choose colours to match the values and start colouring in the numbers, literally paint-by-numbers. This is the first digital image of Mars and it is a drawing, not a photograph.

Made by human hands.

It even has the camera grids, these little crosses and marks in black, which gives the scale. The marks are not on Mars, but they are part of…

…the process. It is mind-blowing. Why is this not at MoMA?

PIA14033: FIRST TV IMAGE OF MARS (HAND COLOURED) (detail, shown here in black and white)
Image courtesy of NASA/JPL-Caltech/Dan Goods

It is on display, I think, in a dark corner of one of the NASA institutes. They do value it. They do realise it is historically important.

Historically important for Space geeks but not as much for linear art-history.

It has this beautiful wash of colour. This is an aerial view of terrain on Mars, so lighter terrain and darker terrain, which I think is amazing and does relate very closely to some of the work that you have been doing. It is breaking down those things into components and then reconstructing them.

The similarities are striking. By the late '60s, quite a few artists were using grids and pixels. Computer language was generally known. But I have never seen this image before or heard it quoted as an influence, or a first.

It has a signature on it by the guy that did the colouring in, Richard Grumm, so he clearly felt that he was the author of it. Or at least that he played a role in creating it. Which I think is really interesting because when you talk about astronomical images - a lot of NASA images or the images that I have made – you feel that there is a sense of moral ownership in a copyright sense, but most scientists don't feel like they are the author, even though creating those images is not a mechanical process. There is this huge input from the individual scientist or the team of scientists creating that image, but then you step away at the last minute and say, *this is just data*.

It comes down to intentionality. Clearly, anyone buying art supplies, making a pastel, and signing it, can say he is an artist. It verges on cliché. The objective here is to see Mars close-up for the first time and that is a team effort which is a way greater achievement than the pastel as such, which then becomes a comment, or a joke on all art, all human achievement. It is groundbreaking and hilarious at the same time. It is really extraordinary.

Yeah, I think it is amazing. It is Dan Goods, NASA's Visual Strategist, who pulls it out of its dark corner and grants it visibility in a larger sense, by putting it online and researching the story. Anyone can now download it from the NASA web site for free and give it a second life.

The recent images from Pluto and the raging debate they have sparked are also really satisfying. In 2015, NASA's *New Horizons* spacecraft became the first spacecraft to photograph Pluto up close. The question this raised was whether Pluto, which used to be a planet but got downgraded to a dwarf, should be upgraded to a planet again, since we now for the first time have realised what a visual and scientific wonderland it is. This is an emotional conversation between scientists but also a very public discussion.

Yeah, I love the way that Pluto and the mission itself have gripped people's imaginations.

The passion in the debate and the very dramatic elements of discovery, betrayal and redemption, you could write an opera with that narrative alone. It is very romantic and completely crazy because here is this geological object that has been sitting there forever, and that suddenly triggers a roller coaster of emotions, *in us!*

Absolutely. And I love how you captured that and turned it round. So instead of being all about what we think of Pluto it becomes, *What might Pluto think of us?*

I thought it would be reasonable to believe that if we are going to project that much emotion on an inanimate object, that it would eventually come alive, resent our judgment and reclaim some dignity for itself.

This spacecraft has been travelling for nine years and it has one day to do everything they need it to do, but it was probably another decade of planning and construction and waiting even before the launch. So people have spent a good fraction of their adult lives working on this thing. It is all for 24 hours of science and they are seeing landscapes on another world for the first time that no human being has ever seen. So for the scientist, this is a massively emotional moment, and because of the way that the media reports science now, they allow and encourage that emotion.

That is why Pluto has been a gift on so many levels. The intrigue and romance around it that reflects back on our own value systems is what makes the discovery so powerful, not just as science, but as a high point in culture too.

I have been giving out the badges that you made, *No Science Without Romance*. This idea of romantic science goes back to the period of Enlightenment. You can see it in Mary Shelley's *Frankenstein*, in the development of the Gothic literary tradition. It uses elements of contemporary science, galvanism, inquiries into the origins of life and the divine spark, *If we can create it, then does that make us like God?* Following that you have writers like Thomas Hardy, artists like William Dyce, using ideas from astronomy to explore the brevity of human life, our fragility in the face of an immense, uncaring, Darwinian universe. But later in the 19th century, science and art and humanities diverge. People start coining titles like *Physicist.*

Specialisations.

Which didn't exist before, and by the end of the 19th century, you've got this world where the sciences and the humanities don't mix with each other any longer, or at least not to the same extent.

Their truths no longer mix either.

Yeah. Maybe you could say that.

People have spent a good fraction of their adult lives working on this thing. It is all for 24 hours of science and they are seeing landscapes on another world for the first time that no human being has ever seen.

Things are coming back together again. I think there is a willingness to connect and learn across disciplines. The difficulty is in learning each other's languages. When I first heard you say, *I got time on Hubble*, I thought you had been in jail.

In the culture of astronomy we say *I got Hubble time*, we talk about *going observing*. If you got the little email saying, *Congratulations, you have been awarded time*, we'd all go down to the pub and it would be, *Hoorah!* It is equivalent to a large amount of funding. It makes you look good in a career sense, but also, it enables you to do some really interesting science that no one else is going to be able to tackle 'cause no one else has the time on the telescope to do it.

Then they move this thing the size of a bus in the direction where you want it and it looks at the Universe for you.

Yeah. You put together this very detailed set of instructions for the telescope. It is then checked and checked again and again to make sure that you're not telling the telescope to do anything stupid, to make sure that what you're trying to do actually has a good chance of answering the question that you pose, and then eventually, it is uploaded into the overall telescope scheduling system, which works out when is the most efficient time for Hubble to do your observations. It may be mixed in with other people's observations because when the telescope is moving around the sky from one object to another, it wastes time, so you work out the optimum way to move around all the different targets from everybody's projects, so it spends the most time actually looking and the least time actually moving. It is a huge amount of planning, by you and your team, by the Hubble technicians.

What an amazing procedure and coordination behind it. You describe the perfect wedding. You are the bride and nothing can go wrong.

Everything has to be perfect.

And yet, sometimes things don't go according to plan and you produce something very unexpected...

Yeah, once I had very carefully selected the quasars (a very bright type of galaxy) that I wanted to look at. I programmed Hubble to point to the exact coordinates in the sky where these quasars were supposed to be, on the basis of other people's previous work. When I got the data I realised that for one of the objects, the image was blank. I mean, there was the usual electronic noise but right in the centre of the image where my quasar should be, there was *nothing*. Turns out that the coordinates in the quasar catalogue were wrong. There was a typo in the published source data and I had taken this quite expensive picture, this blank piece of sky, which was not very useful in terms of the science.

This has a massive value in terms of art.

It is like the John Cage, *4 minutes 33 seconds* kind of thing. What do you see when you look at just Space.

Where is the picture?

It is on the Hubble archive. We could download the data again and try and do something with it.

Okay. Let's print the image and show it.

I think that would be fun because I never published that data. I basically just said this quasar is excluded from the discussion.

Because your science wouldn't value you staring into the void.

Yeah, exactly.

Art does.

One of the things I really enjoy about our interactions is that you make me look at things in a different way. It is only by interacting with other people that we can switch perspectives, even if it is temporarily.

Imagine what a future version of you could make out of it. You could be a scientist on a spaceship who has devoted his career towards collecting data on the most advanced equipment, but at this particular moment, you might take a picture of seemingly nothing and immediately validate it as art yourself, because you know about John Cage now, and you live in a future that is fully interdisciplinary and doesn't require a separate context to appreciate what you have just done.

Well, now I'm very excited to be getting that data back and actually do what I didn't do before, which is presenting the image of seemingly nothing to people and saying, *I made this. It is a thing.*

It is only by interacting with other people that we can switch perspectives, even if it is temporarily.

It is radical! We need pauses between words to read sentences. Voids are essential, because voids are not nothing. Nothing is nothing! This is what John Cage was listening out for. You are already there. You won the time. I couldn't do it in a million years but I can title it. *Stare into the Void* should be in a museum, next to all those other artworks that celebrate voids.

Let's do it.

Aleksandra Mir
NO SCIENCE WITHOUT ROMANCE
2" badge, unlimited edition, 2015–17

MAREK: Success – I've managed to find some simple software for Macs that will display data from the Hubble Archive and then export it as a jpeg file.

ALEKSANDRA: That's the best news I have had all year!

It is just a display programme and it doesn't allow you to process and manipulate the data or to remove defects.

Good!

The data in the archive has already had some basic processing applied to it but the images still contain some electronic noise from the digital camera chip itself: i.e. they are not just showing what is out there in the sky but also some of the random flaws of the camera itself. I like the authenticity of this, because it harks back to our discussion about how an image is never a *pure* representation of the external world but always has some aspects of the imaging process imprinted onto it – the camera's own signature.

The camera signature manifests itself in several ways: the dark *cross* that divides the image into four sections (a result of the way the digital chip reads out its data); the pale and dark regions in the two upper image quadrants (these are regions of the camera chip which happen to be slightly more and less sensitive respectively); the scatter of bright white dots (these are broken or *hot* pixels which are not responding to incoming light but are permanently charged).

You could liken this to looking out through a dirty windowpane – most of the detail you're seeing is on the glass rather than in the scene outside. Or, if you want to make a sonic comparison to John Cage's 4'33" then perhaps you could argue that these camera *artefacts* are like the ambient sounds of the audience and the concert hall, that only become noticeable because of the silence of the music itself.

It is not what you had originally intended but it turned out beautifully!

I intended to point the Hubble telescope towards a quasar called 1148+56W1, around 24 billion light years away, which I expected to appear as a bright blob in the centre of the frame, surrounded by a halo of fainter infrared light. But the sky coordinates that I obtained from the catalogue were slightly wrong and as a result the telescope spent 2.28 hours pointing at a patch of blank sky – there are no stars, galaxies, quasars or other objects visible in the image. The smooth background *fuzz* is a combination of the camera and the sky – random variations in the sensitivity of the individual camera pixels plus the wash of very faint radiation coming from deep Space: the void.

Congratulations!

I'm really excited to see the data again after nearly 20 years – and with a whole new way of looking at it.

If you are showing me the highest resolution it will print at about only 5 cm wide though...

The image is full resolution. The NICMOS camera chip is only 256 by 256 pixels square – this is early 1990s technology!

Marek Kukula
STARE INTO THE VOID
2017

Infrared image made with the Near Infrared Camera & Multi-Object Spectrograph (NICMOS) on the Hubble Space Telescope through the F165M Filter with a total exposure time of 8192 seconds (2.28 hours) on 30th June 1997. NIC1 array, 256x256 pixels (11x11 arcsecond eld of view). HST Programme ID: 7447.

Assistants Yasmin Falahat, Denis Shankey and Simone Russell
Aleksandra Mir Studio

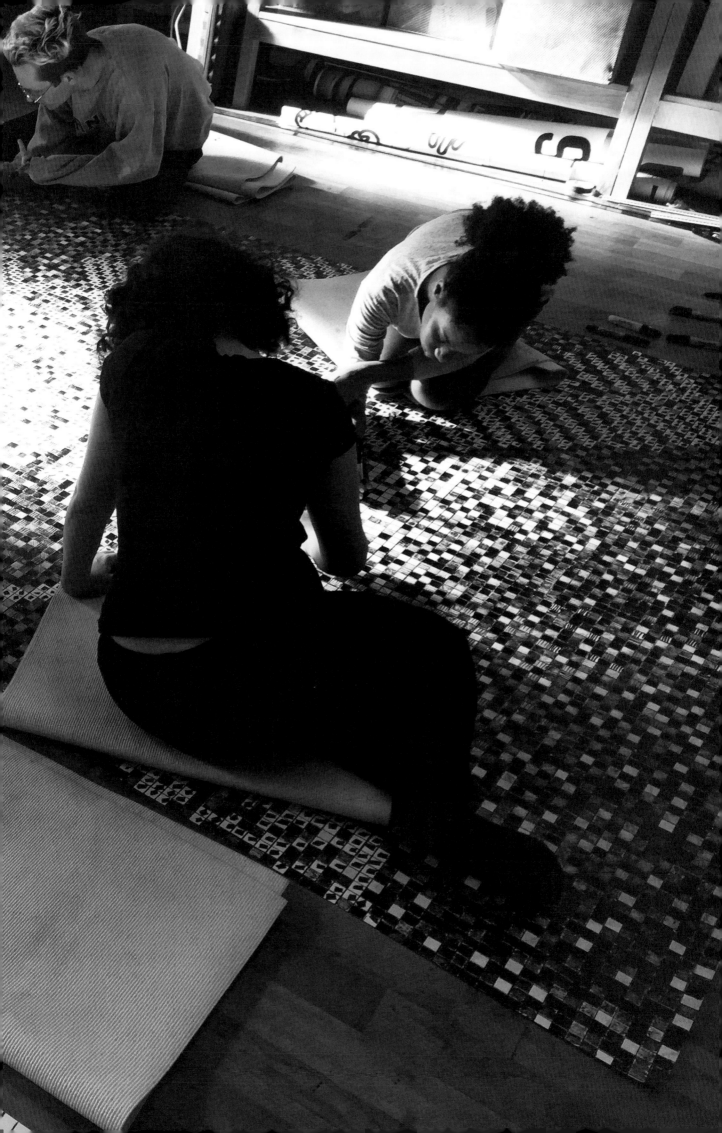

Colouring for Phenomena

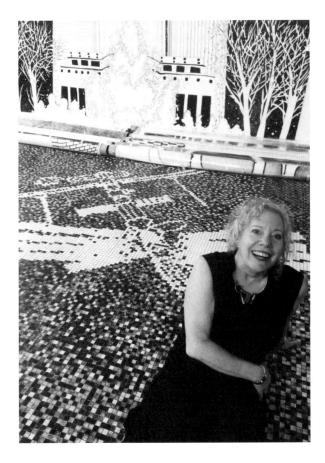

JAYANNE ENGLISH is an observational astronomer who studies how galaxies evolve over time. Her training as a visual artist was invaluable during the two years she coordinated NASA's Hubble Heritage Project, which uses data to create striking images for the public. She is an associate professor in Physics and Astronomy at the University of Manitoba.

Aleksandra Mir
RING NEBULA
fibre-tipped pen on paper,
layered and inverted in
Photoshop 21x30 cm, 2016

ALEKSANDRA: I had this preposterous idea that I could reinvent the Hubble aesthetic but I had no idea of how to access the data or what to even start looking for in the sky. You agreed to spend a week in the studio to give me a 1:1 workshop. Why?

JAYANNE: Well, I didn't want you to attempt to do this on your own because I feel a responsibility to ensure that the information presented to the public about what astronomy image-makers do is accurate. You were clearly serious and curious about attempting to participate in Space science so I wanted to help you acquire a trustworthy understanding by providing some relevant hands-on experience.

The Hubble images are incredible popular.

The Hubble Heritage project was started up in 1998 by Keith Noll, then at the Space Telescope Science Institute in Baltimore, which runs the Hubble Space Telescope (HST). Impressed with the immense popularity of the *Pillars of Creation* (Eagle Nebula) image, he gathered together several institute astronomers to create monthly press releases of HST images. One was an amateur astronomer and the rest had research degrees – they weren't software jockeys or artists. Amongst other things, I was the initial coordinator. I am a trained artist, as well as a research astronomer, so I introduced the team to visual art techniques. Our goal became to disseminate science-rich images that caught the public's eye because of their aesthetic – they did not need to be newsworthy but they did need to represent the scientific results of our colleagues.

Not without drama.

Our images became part of NASA's many years of promotion of HST as the best telescope ever and it turns out that this promotion had political clout. When it was announced that Hubble Servicing Mission 4 would be cancelled, because the Space shuttles were to be retired, a huge public outcry ensued. The NASA administrator who made the announcement was replaced and the servicing mission re-instated.

I always have mixed feelings towards these images. I am really impressed with the gazing part, the technology that allows us to see so far, but why do the final images have to look like curtains?

Curtains!? The HST images are made by scientists who rely on their intuitive aesthetic preferences. And of course these are influenced by popular culture. In my opinion, scientists start off as *naïve* or *visionary* artists. I am frequently invited to scientific institutes to give colloquia and workshops on how to apply composition and colour theory to scientists' data. This probably means that their eye-candy will be more engaging but they still refer to their favourite movie posters. I don't mind this because their intention is not to make art and because their pieces become more successful as public outreach.

How does data enter the picture and what are the formal parameters of an image's construction, framing and retouch?

Data are acquired in different energy ranges such as ultraviolet, blue, green, red, near-infrared, etc. Note that some of these are outside the visual range and by definition do not have colour. The selection of a range is accomplished by placing a filter in front of the camera. The result is that we end up with a black and white image per filter. The filters are chosen according to scientific criteria, not picture making notions. For example, if you want to detect hot, young stars then you would observe through the blue filter. Then we typically *stretch* the data to compresses the information and in order to show bright and faint features simultaneously. The grey scale

Aleksandra Mir
RING NEBULA
fibre-tipped pen on paper
21x30 cm each, 2016

> *The Hubble Space Telescope images are made by scientists who rely on their intuitive aesthetic preferences. And of course these are influenced by popular culture.*

stretch from each filter is put into its own layer to form a stack of layers. Each filter is then assigned a colour and the display of the combined image is exported to a single file. Now we orient and crop the single image to produce a composition that will retain the viewer's attention. We adjust the intensities and colours for contrast and saturation and finally we remove cosmetic defects.

How many people work on an image and what is the team structure?

These images can be constructed via a *pipeline* by many people using many different software packages. Image-makers work in teams as small as two people but up to several, sometimes including the scientists who acquired the data. While I do all the steps, the Hubble Heritage team consists of several people who divide up the workload so that one person does the stretching, another does the colour assignments and composition, and yet another the cosmetic corrections.

And what is the process of approval before images are released to the public?

We will make a few different versions with different colour options. Once the team settles on a palette, the

The scientist has a different understanding of colour than the public does.

layers are rigorously adjusted. The team then considers a variety of orientation and other composition options. The final composition is shared with the astronomers who acquired the data to confirm that the image highlights their discoveries. For example, if they discovered hot young star clusters, did our adjustments of the blue filter show their presence and distribution across the field of view sufficiently? Colleagues at the institute also make their voices heard about both the science and the aesthetics of the outgoing image.

You mentioned using *Colour Theories*, what are they?

The scientist has a different understanding of colour than the public does. For example, the layperson considers blue to be cold (and *cool* is also the term used for bluer colours in art). However if you look at the base of a candle flame it is blue, and this part is hotter than the red or yellow part of the flame. As an astronomy image-maker you have to decide if you want to communicate hot and cold in your image by using red and blue in a painterly way or if you want to be pedagogical and communicate the information that blue stars are hotter than reddish ones. Multiple renditions of the same astronomical data are equally valid.

This is also where the confusion begins. I have a bookshelf on colour in art and through art history, and from what I can gather, there are as many colour theories as there are colour theorists. I think colour is not only subjective, but overrated!

Well, I encourage the use of colour to create depth and harmony since it can ensure right off the bat that the image will engage the public. Colour is also critical for coding the scientific information. That is, each filter captures photons that tend to come from a dominant physical process – so a near-infrared filter detects the light from old stars while the blue filter traces mainly young stars. Assigning colours to those filters allows the viewer to discern the age of the stars in the image. In this way, both the science and the visual language can co-exist without detriment to each other.

The so called Hubble Palette is only an amateur astronomy convention.

Are there any official doctrines or constraints?

Fortunately there are no formal guidelines given by NASA or the European Space Agency. Hubble images do not stick to a one-size-fits-all colour legend. We found that every astronomy target and its scientific information needs its own specific visual descriptions. The so-called *Hubble Palette* is only an amateur astronomy convention. On the other hand, colleagues want us to produce something that they feel will garner them respect, so cut and paste and fancy manipulations are out. The current leader of Hubble Heritage, Zoltan Levay, likes to restrict the manipulation to the digital analogues of dodging and burning from the days of film photography.

I have been working entirely in b/w for a long time, coaxing out a really rich and dynamic palette with fading Sharpie markers and a variety of energies and textures. So I wanted to propose an alternative aesthetic to the candy colour schemes, but with the same scientific credibility. You were at first doubtful it would work.

True! I thought the blending of black lines would simply obliterate the scientific information. But I am a scientist so I wanted to do the experiment of using texture instead of colour in the individual layers. I was so pleased when it worked – more pleased than you were!

It was much harder than I could have imagined. We struggled for three days to find common ground. *Interdisciplinarity* is this beautiful idea of collaboration, but my experience of straddling the two disciplines was to play expert on one hand and resort to being a baby in the other, a limping sensation that was utterly frustrating and draining on both the mind and the ego.

I was surprised that you didn't even know basic image manipulation software when we started. It was like

taking a professional through the ABC! We had to begin by installing and teaching you how to use command-line professional software too. I was proud of how we got through all the technical challenges but there was a point that I was afraid that we wouldn't make it to the main work.

I know. It was embarrassing to have to waste your time on teaching me this, I tried to compensate by buying lunch!

Okay. It was intense and tiring, I agree, but also informative and clarifying. I loved the challenging discussions. It became clear that we wouldn't complete an image that was presentable to the public. However the experience could also provide fodder for potential publications together. Such an article would be rich due to the contrast in our perspectives.

At some point I was so exhausted I said I don't even believe these things we are looking for in the data are even real!

Galaxies are as real to me as this table! LOL!

It was a transition from simply thinking about the surface of images. It doesn't mean I questioned astronomy's relevance, but it was the first time I actually had to engage with its processes, to enter into a relationship with it. You also taught me a bunch of fascinating new terminology, such as *Visual Regime*, that I love!

It is in standard usage in astrophysics for regions of wavelength (i.e. energy) categories in the electromagnetic spectrum: *X-Ray Regime, Optical Regime, Infra-red Regime, Radio Regime*. Charmingly, the slippage of language has opened up an unintended arena for thought. *Visual Regime* as in *Region* or *Territory*.

Or, *Visual Ideology*, the power embedded in looking, to manipulate or be manipulated by. I suppose every artist imposes a regime on themselves as a way of defining their area of agency. It does get territorial. I have claimed the regime of the fading Sharpie marker for myself, which is a dumbed down and anti-authoritarian regime full of flaws. Are the regimes of astrophysics waterproof?

Oh no! The names of regimes are useful conventions, though their boundaries have physical implications. For example, radio regime photons cannot be reflected by a regular telescope's mirror – we synthesise a mirror out of radio antennas to collect and focus those photons. Before the mid-20th century astronomers did divide themselves into regimes but when I was a graduate student I worked in optical and radio regimes and now I used infra-red and microwave too. Many astronomers now call themselves *multi-wavelength* astronomers.

Galaxies are as real to me as this table! LOL!

After three days of hard work and lots of drafts, we finally came out with this shy and limp little drawing that actually hit the target. It did what you wanted it to do and it looked the way I wanted it to look.

I REALLY like the line-drawing layer experiment. That is really original! Not a finished product, but as a pilot sketch it really is illuminating and provocative. I was so surprised that it worked.

I thought, okay, if the function of colour in these scientific images is to distinguish between phenomena, say, a variety of temperatures, then I know I can eliminate colour altogether and retain the contrast and definitions by simply working with b/w textures and densities.

This is the revelation here since Hubble Heritage and other image-makers rely on colour to describe different phenomena and your b/w drawing does that successfully. And one phrase that came out of our discussions that is significant for me is *Colouring for Phenomena* rather than *Colouring for Contrast.*

So let's consider that a breakthrough. Now we only need a huge grant so we can focus on nothing but novel observations and labour intensive hand-drawn images. And this is where I hit a brick wall when I realised it would take us a decade of collaborating to fully achieve groundbreaking results that would be satisfying to the wider realms of our respective disciplines.

We came much farther along than I expected we would. I'm not sure it would take ten years to produce something that would have validity for NASA or other scientists, but certainly it would take a few!

I really want to thank you. It gave me an incredible insight into a very advanced process I was utterly ignorant about and that is also much too advanced for my resources. To come up against one's limitations, only to determine what they are, is also very useful.

Every step was an achievement, even those that didn't advance the image we were attempting to make. Unexpectedly we had an *alternative* achievement too, which was finding one possible way of connecting black and white drawing with the astronomical *photon-graphs*. I'm pretty chuffed with that!

By clowning around and accidentally finding a goldmine.

It doesn't matter that the images are rough sketches – they are so original and a proof of concept for a potential direction for art that could be meaningful

in a scientific context. For example, lines are used in figures for tracing magnetic fields in galaxies. What kinds of lines and textures should we be using? Should we be using lines at all? I will be taking this back to my colleagues!

Of all the images from your own work that you showed me, I tended to appreciate those you had discarded. I love the dirt and the dust that is retouched out of the images as I think it is valid to show how hostile Space is, not this wonderland of swirling ice-cream-like galaxies expecting to be licked. But that is just my personal preference.

The Hubble Heritage Team's version of Hickson Compact Group 87 (shown here in black and white). The 3 larger galaxies are interacting gravitationally with each other. They were observed using the Wide Field and Planetary Camera 2 instrument, which consists of 3 wide field cameras and one camera with finer detail but a smaller field of view. This latter camera, in the top right corner, causes the overall image to have the chevron, or stair-step shape.

I am always more drawn to everyday grit than glamour that fails to keep my attention.

I made an image back in the day that shows the chevron shape, which I think you will appreciate! Check out the top right hand corner of Hickson Compact Group 87!

Exactly! This odd geometrical shape that emerges from the limitations of the telescopic view before the final image is neatly matched up and pasted together. It is an entirely native and unique format. You should keep it.

There is the worry that if we leave in the noise or the signs of the telescope, the public will be confused. They won't be able to distinguish between a real feature that we want to point them towards and an imagined alien or an optical side effect or artefact from the digital imagining process.

Rather than worrying and obscuring the process, I think you should make what you are doing and what

tools you are using to get there even more overt. I don't understand why science has to be so slick and heroic all the time. Would it not evoke more interest and sympathy if you could share its vulnerabilities? I think this is where art and science could eventually meet. The public will just have to follow, and they will.

Maybe you are right that they will follow. But I think this would take a high profile interdisciplinary project whose goal is to educate the public. And it would really depend on the audience. An already educated audience of citizen scientists would eat it up but others would use it to dismiss the science as invalid, just as they dismiss climate science. It would be a scary experiment to do!

I completely understand the fear, but there is a big difference between acknowledging that science is made by humans with personal biases, and discrediting their results entirely. The objective here is not confrontational but complimentary to the scientific truths. Hubble images are often considered to be fine art, but let's be honest here, and it is a question of intentionality, the purpose of Hubble images is to *sell* the science of the telescope, not to advance aesthetics or critical thought.

I consider Hubble images public engagement. I have been wanting to articulate more rigorously why public outreach images are not art and you've provided me with both language and notions.

Public engagement comes with its own brief, restraints and outcomes. I would like to see images that push both science and art without those restraints. Marek Kukula, Public Astronomer at Greenwich Observatory who is heavily invested in both realms and who introduced us, also told me about John Russell who was an 18th century Royal Academician and an amateur astronomer. Russell created these very emotive pastels of the Moon which at that time also become the most scientifically accurate depictions of the Moon anyone had ever made. One person could achieve that then, while today it would require a team effort.

Science continuously informs art. I also was thinking of outreach images in terms of *selling* this morning. Outreach image-makers are into *persuasion*. Persuasion that the target exists (e.g. a group of odd looking galaxies), that the phenomena emphasised exist (e.g. tails produced by gravitation tides, a burst of star formation), that the telescope is adequate for making discoveries and should be funded, etc.

People already interested in this stuff are hopefully willing to be educated and to go further, not just be passively pleased or persuaded.

We are also starting to make a distinction between Public Outreach which has strong elements of selling and persuading as well as simply explaining, and Public

> *An already educated audience of citizen scientists would eat it up but others would use it to dismiss the science as invalid, just as they dismiss climate science. It would be a scary experiment to do!*

Engagement with Science which is much more of a two-way process or conversation, with the idea that both scientists and the public might benefit from the exchange in various ways.

How do you promote that?

I am sure I have given the workshop to 100 amateurs, more than 20 artists and a couple of hundred undergrads. I post some of their results on my website, which is some kind of validation though I don't have time or funding to organise a book or exhibit. People use it as they will or won't. With respect to HST, there was also a competition for public-made images from the Hubble legacy Archive called *Hidden Treasures*.

I haven't even looked, but I bet they just look like bad copies of existing Hubble images. This is the elephant in the room: because astronomy depends not only on telescopes but computers and software to access these objects, the technologies limit the playing field between us and the target. What frustrated me the most about our workshop was the software that locked us into a prescribed way of looking and treating this information without any way of demonstrating its limitations. As a user you simply can't go beyond it to make a radical shift from within the computer. This is why I insist on taking it out of that environment and bringing in the hand at the cost and benefit of my bias.

Perhaps in a way we are locked into a way of seeing and thinking by software – a good example are the false colour lookup tables that don't support our perception of forward and backward motion for example. However we do go beyond one software package to *workflow*. It is like making pancakes. I move from bowl+whisk to a frying pan. A better frying pan won't change the pancake to muffins. A waffle iron produces an equally valid *pancake*, though not an improvement – pancake and waffles are equal.

Perhaps future software developers will unlock those barriers and allow completely new images to emerge, again, somewhat automatically. Someone will find that key and so for now, we can only wait for that someone.

Where we are going in astronomy imaging is the 3D immersive VR visualisation environment that I am

THE MOON, VIEWED IN FULL SUNLIGHT
Stipple engraving, 1805, by J. Russell after himself
Image courtesy of the Wellcome Library, London

also involved in. Rather than producing 2D images it produces *sculptures*. (I am not sure soufflé' would be the right metaphor for extending the pancakes schematic). Another is to combine images from different telescopes – this is the new regime and this is what we did with one of our last images that we made together. This is one breakthrough realm.

Our exchange has created some interesting freaks that need to be reined in a bit more to be valid as artworks. I have learned a lot but it is one of those scenarios where the more you learn, you realise you don't know anything. So many of our goals are set on opposite ends, and this in the most friendly, supportive, non-commercial setting imaginable. I can only imagine how demanding a pursuit it would be to advance science on a larger scale. I don't have it in me, so after this, I will need take break from astronomy altogether.

I appreciate that you are taking a break from astronomy – you really did unknowingly set yourself an extreme challenge and you now have to digest how big that challenge is. But you can pass this information and this experience on to others who are curious, and it may inspire them to take on an endeavour which produces results of significance in both the art and science realms. And you can get back to me when you are interested again – I'm sure we can do other projects and this time I know we need spread our project out over more time!

You are a great sport!

And you are a great inspiration!

Aleksandra Mir
GET ON DA SPAZE BUZ
fibre-tipped pen on synthetic canvas
300x600 cm, 2015–17

It is in our genes to leave and explore new worlds

JAN WOERNER is the Director General of the European Space Agency. A German civil engineer, university professor, and former head of the German Space Center, he has a vision to open up the Space Agency – to interact with the general public and to engage them with the Space industry.

ALEKSANDRA: I was very impressed when I first heard you speak about Space 4.0. Where I'm coming from, the art world, we divide our art history in periods. We have the *Classical* and we have the *Modern* and now the *Modern* is over 100 years old. So we have *Modern Classics*. It gets very confusing.

JAN: For me, yes.

We also have museum departments struggling with the preservation of ageing *New Media*. I'm a *Contemporary* artist, but watching myself ageing, I can easily tell that the *Contemporary* is not going to last forever. Calling my work *Art 1234.5 Version b* would be more practical. How did you come up with the idea of using decimals to describe the periods of Space history?

Some people still use *Old Space* and *New Space* for what they believe is the difference between early exploration and the era of commercialisation, but that is already a 30-year-old story. I never used it. Space 4.0 is something entirely different. I make distinctions between Space 1.0, 2.0, 3.0 and 4.0.

Space 1.0 is *early astronomy*. Space 2.0 is the *Space Race*. Space 3.0 is the opening up of different applications, such as Earth observation and navigation. And now we are entering the phase of Space 4.0, which means we have totally different actors: not only two superpowers going into Space, but also over 70 Space-faring nations worldwide.

Space 4.0 is our day-to-day infrastructure with telecommunications, exploration and science. Space 4.0 is also commercialisation and participation, meaning that, in the past, the governments or the agencies of the superpowers decided what to do. Today and in the future, more and more people are using Space and will be directly influencing Space. Therefore Space 4.0 is not about a *new* Space, but looking to the future and a new world.

As an artist, of course I'm very interested in finding out how the arts and humanities can play a role in this evolution.

Aleksandra Mir
FIRST WOMAN ON THE MOON
Produced by Casco Projects, Wijk aan Zee,
The Netherlands, 1999

When I talk about the fascination of Space, I'm not restricting it to STEM (science, technology, engineering and mathematics) but I say *STEAM*, where the A stands for art. There are a lot of examples where artists are using Space as a part of their work. Questions raised by studies in the Space domain can provide inspiration for artistic exploration, which in turn can offer fresh perspectives on the science.

In my former job, I was the head of the German Aerospace Centre. We invited artists to participate in parabolic flights and to use Microgravity for their own activities in art and music. At ESA we have worked with the French urban artist, *Invader*, who applied his special brand of *Space mosaics* at different ESA sites, and with the composer Vangelis for his latest music album *Rosetta*.

We've worked with photographers such as Edgar Martins and Frans Lanting, and contributed to many exhibitions around Europe. We operate *artist-in-residence* programmes, where artists work at ESA sites alongside their technical and scientific counterparts, in innovative areas such as interactive art, sound art, animation, film and visual effects, hybrid art or performance and choreography, for example.

The humanities also include history, so we should not forget our history project. This aims to record the European collaborative Space programme from its beginnings in the late 1950s to the present, as well as finding creative ways to tell a modern-day audience about the fascinating achievements of days gone by.

You have a vision for the Moon Village, which I understand is not a literal village on the Moon.

The Moon Village is where different interests come together, where one tries to have a joint understanding of doing something together. It is a concept, not a project. And the concept is not a single concept. It is not a plan for an end. It is not a fully fixed thing. It is an open architecture, an open idea, allowing access from very different players, whether they be robotic or human, whether a company or the public, whether individuals or the Space-faring nations.

Anybody can basically assign themselves to this project?

Yes.

There is no restrictive committee?

No.

I did a project 17 years ago called *The First Woman on the Moon* and if you Google, *Who was the first woman on the Moon?* you still get my name I'm sorry to say. Of course, it keeps me very busy but it is also a bit embarrassing on behalf of humanity that you are now sitting here with an artist and not an astronaut who has this title. In 2014 I heard at a conference in London, David Willetts, the former UK Science Minister, make an educated guess that the first woman on the Moon

> ## *The Moon Village is where different interests come together, where one tries to have a joint understanding of doing something together. It is a concept, not a project.*

would be Chinese. I realise that gender politics is not a reason to launch a Space mission but I am just very curious, why would ESA not take the opportunity to make her, say French, even as a PR exercise?

We have female astronauts in Europe. One is sitting in an office above me here in Paris right now: Claudie Haigneré is French. We have Samantha Cristoforetti from Italy, and in Germany they are now also looking for a female astronaut. I don't think this a gender competition. I think what David Willetts wanted to say was, *Be aware, China is very rapidly taking its opportunities in Space. They are very successful and maybe they are also soon going to send humans to the Moon.*

There is a symbolic value in making the point of the woman.

Yes but, for instance, consider the image that the ESA created for the Aurora Exploration Mission, which was a human spaceflight programme to explore the Solar System, it shows a spacecraft and a female astronaut. So yes, we are aware, but I don't think that it matters whether it is a woman or a man, or British, German or Italian who will be the first. For me, it is not about the competition at all.

If you listen to the young generation now, they want gender fluidity and advanced medical science together with shifting popular opinion is already making that possible. So if we wait too long in sending a woman to the Moon, it might not be a man or a woman. It might be something completely different. In your vision of the Moon Village, is there going to be a population of some kind?

It may happen, but the Moon is not a very nice place to stay because you have very long nights. From that perspective, it is not the best environment for humans to be in for any long period of time.

Well nothing beyond the Earth is, really? I mean, is there a reason for us to leave at all?

Yes. It is in our genes to leave and to explore new worlds. People climb Mount Everest. Is there a need to climb Mount Everest? No, there is no necessity, but it is in our genes to discover the unknown.

Master of Space Studies students participate in Aleksandra Mir's *Failing and Falling: A Workshop on Gravity*
International Space University, Strasbourg, 2015

The economy of nature

CLARA SOUSA-SILVA is an astrophysicist studying how life on alien planets interacts with light. Clara works at the Massachusetts Institute of Technology, in Cambridge, USA.

ALEKSANDRA: Wow, you look like Einstein 2.0, or maybe that should be 20.0. Do you stand on the shoulders of giants or are you a breath of fresh air?

CLARA: I have a very vivid image of this analogy. I imagine myself, and every other scientist, perched precariously on the shoulders of many giants standing in a circle – them looking in, us looking out. Without the giants we are nothing, but we are the ones working in the void.

You are breaking new ground just by being there, have you also broken any rules?

Like every other scientist I feel the pressure to come up with something original that nobody else has ever done before. I think I am the first to call myself a Quantum Astrochemist, since the fields of quantum chemistry and astrophysics rarely come together. I use fundamental quantum physics to simulate molecular spectra so that we can remotely detect those molecules on other planets.

Is the work lonely?

A little. But that is the nature of it. If there are two people working on the exact same problem, then one of you becomes redundant. You can collaborate, but not too closely, because again, one of you becomes redundant.

You assign yourself to your own problems. You arrive to work, there is a clean desk, a computer and they say, *Do whatever you want!*

Yes, and I have my own blackboard.

Nobody can touch your blackboard?

Nobody. There are very precise instructions to the cleaning staff, what they can and cannot touch.

That is way ahead of the art world where priceless art that looks like dust balls gets thrown away by cleaning staff in museums all the time.

Aleksandra Mir
SOLAR ORBITER
fibre-tipped pen on synthetic canvas
300x400 cm, 2015–17

> ## When I came here to MIT, I asked the same question, How long do I have to resolve this? Two weeks, 20 years? And they just said, Work on it.

Somebody probably cleaned out a Nobel Prize winning theory written on a dirty napkin once and then they made the rules after that.

But you are hired to achieve something very special.

Find alien life.

Any particular timeframe for that?

Well, that is what is so amazing. When I came here to MIT, I asked the same question, *How long do I have to resolve this? Two weeks, 20 years?* And they just said, *Work on it*. In the beginning I was overwhelmed with all this freedom. It was almost too much. So now I give myself smaller problems to resolve.

What is the day-to-day problem?

We are looking at the various conditions for life, maybe different life from our own, so it is a large and many-layered problem. There is another scientist in my department who looks specifically at the basic chemistry of life, and whether the life we know was inevitable or whether there was a variety of chemical paths that we could have followed. When we have an idea of what kind of chemistry life likes using, we can guess what molecules it likes producing. Then my job is to figure out what those molecules look like when they interact with light so that we can detect them remotely. Each molecule has its own peculiarities, and I spend a lot of time, sometimes many years, with each one.

What is the broadest definition of life?

Well, that is a *big* discussion, a lot of people have different ideas. We do our best not be too geocentric, but the fact is life on Earth is all we know.

That being said, alien planets can be drastically different from ours but not infinitely so. The whole Universe still has to use all of the same elements from the periodic table, and the same laws of physics will apply no matter where you are.

But the most *basic* definition of life is one of the economy of nature. At almost every scale, from the quantum states of a single atom to the interactions between stars in a galaxy, nature tries to save energy. Complexity happens because it is more energetically sound for two molecules to merge together than it is for them to be apart. Chemical reactions occur for the same reason, and you can extend this argument all the way to the life we know.

That sounds a lot like the dating and housing market. It is very romantic. Romantic in a utilitarian way, not in an unachievable way.

Utilitarian romance is my favourite form of romance.

Is romance important in your work?

I do not think it is possible to remove romance from the exploration of alien worlds. In his book *Pale Blue Dot*, Carl Sagan says, *We invest far-off places with a certain romance. The appeal, I suspect, has been meticulously crafted by natural selection as an essential element in our survival. It is our restlessness that drives discovery.* There's a human desire to explore and exoplanets are the ultimate distillation of that impulse. In the past our conquering of new lands has not been without suffering; my hope is that, when we take our restlessness into Space, we don't let romance cloud our judgment.

> ## We do our best not be too geocentric, but the fact is life on Earth is all we know.

You use data. What is data and is it negotiable?

Data is the extraction of information from events. At its purest form it is non-negotiable, but humans can rarely access it directly. We have to make approximations, and there is probably not a scientist who doesn't feel a bit guilty about their approximations. You can consider that a scientist's ultimate aim is to minimise how negotiable their data are. When different approaches to the same data yield the same conclusion – that's what truth is.

What is the relation between theory and practice?

In most interesting questions, theory and practice often don't match. If I only worked with science where theory and practice are in complete agreement, I would only ask very boring questions. Ask me to predict how high a ball will go if I throw it, and the theory and the practice will be indistinguishable. Ask me to predict whether a planet on the other side of the galaxy is habitable or not, and not only will the theory not match the practice, but both will be riddled with unknowns.

But the point is for them to eventually match up?

Yes and when that happens it is so amazing, the greatest sense of satisfaction. When I was at the beginning of my PhD I did my first full simulation of a molecule,

> **There is a human desire to explore and exoplanets are the ultimate distillation of that impulse. In the past our conquering of new lands has not been without suffering; my hope is that, when we take our restlessness into Space, we don't let romance cloud our judgment.**

Phosphine. I knew what it was supposed to look like, as it had been measured in a lab before, and my job was to use fundamental quantum mechanics to match the experiment. Simulating a molecule theoretically is too difficult to do completely, not just mathematically but because big enough computers simply do not exist. I had to use many approximations and cut a lot of corners to get my final spectrum, and each weighed on me. By the end, I felt that I must have moved so far from the truth that my work would be meaningless.

But it wasn't – I had simulated reality! It felt so powerful. Now I trust that science works; when I simulate a molecule and I know its fingerprint, I expect observations of that molecule on an exoplanet to match my predictions.

It all sounds so effortless when you hear the success story. What has your journey to get here been like, any obstacles on the way?

Only ten years of hard work. I think I did everything I was supposed to do. As a woman, I had a very good advisor at UCL (University College London) who recognised that the world of science was not very representative of diversity, so he levelled the playing field and gave me a good chance. Before then, on conferences, I was often the only woman physicist and I could sometimes feel that I was questioned in a way that a man wouldn't be, and I felt I had to represent all women. But now at MIT I am in an environment with plenty of women and I can just be a scientist.

You have arrived. You are IT.

Yes, I am IT.

How old are you?

Ahem, 30?

You have a long way ahead to be IT. But what if you will never resolve the big problem in your lifetime?

I can live with that. All I want is to be useful and advance things for the next generation. I have already made my own 12-year-old self proud. I decided to become an astrophysicist in Portugal when I was 12 and my mother showed me a solar eclipse. She had read about it somewhere and could predict what would happen minute by minute. I didn't believe her but then everything happened exactly the way she said. It was the coolest thing. I felt like it was the greatest power imaginable, and I wanted it.

Knowledge.

Knowledge.

Aleksandra Mir
PIONEERS
photocopy collage
21x30 cm, 2015–17

YES

E ARE ALON

IN THE UNIVERSE

W

We search the Universe to find ourselves

JILL STUART is based at the London School of Economics and Political Science. Her research focuses on the politics, law, theory, and governance of outer Space. She is also the Director of METI International.

Aleksandra Mir
YES WE ARE ALONE IN THE UNIVERSE
fibre-tipped pen on synthetic canvas
300x600 cm, 2015–17

Aleksandra Mir
PIONEERS
fibre-tipped pen on paper, photocopy collage
21x30 cm each, 2015–17

ALEKSANDRA: Welcome to my studio. I have 6 months left here. We got our eviction notices last week.

JILL: This is a beautiful building, what are they going to do with it?

It is going to be demolished for redevelopment.

Oh my god. Are these your Sharpie drawings? This is so freaking cool.

I think you are the most excited person that has ever been here.

Just to see one on this scale is incredible. Where is this going to go?

This is not going anywhere. I have already filled every square inch in two museums and we are still making work in the series that is not going fit on the walls. This is going straight to storage and so the opportunity of having guests here and at least take a picture…

I would love that. To be photographed with one of these. They are incredible. Do you mind if I plug my phone in to charge?

Just don't forget it when you leave.

I know I probably will.

Because I have had so many young people come and work with me and one constant crisis here is, *I forgot my charger!*

It sucks that you have to go.

Yes, but it is also an incentive to make the most out of it. I am going to go out with a bang. I look forward to figuring out the next phase of my life.

Are you going to leave the UK?

Not unless I am asked to.

Why would you be?

Why even have to think about it? I have maintained a relationship with London since I was a teenager in the '80s, when you had to take a 24-hour ferry from Gothenburg where I grew up to get here. I have worked as an artist all over the UK since the '90s, when nobody asked, *Where are you from?* but, *What are your ideas?* I am 50 now and I like my bus route. I don't need a bigger reason.

Of course.

But this studio situation is actually more pressing. When I walked in here four years ago nobody wanted this space and now it already feels like the end of an era to be working at this scale in Hackney.

London is always changing and the East is very much the spot right now. So are these all works on the floor or is there more?

That is only a small part of it. Most are already in storage because I live in constant fear of causing a big fire. But I actually want to talk about you now.

Okay, I am an expert in the politics, ethics, and law of outer Space exploration and exploitation. I initially wasn't very comfortable with the phrase *expert*, but I am actually endorsed by the Home Office, as a world-leading expert, in my field. I used to have an exceptional talent world leader visa.

You are American.

I am. I have been in the UK for 17 years. I left the US when I was about 18. I grew up on an Indian Reservation in rural Oregon but got out as soon as I could. So I lived all over but then settled in London in 2001. I don't know your own immigration history, but I was nearly deported in 2010, but yeah, here now.

What was your education like?

I studied Political Science at university. I was taking an International Law course and we were assigned to do a generic essay on International Law. So I went to the library, back when it was more common to go to the library, to the International Law section and there was an oversized book, stuck on its side, and it said *Space Law*. Until that point it didn't even occur to me that such a thing existed but I was hooked.

What year was this?

1999 or 2000. I was surprised that we had already established a system of governance for outer Space, and if so, *Why?* If so, *What?* So initially, I was looking at the international legal infrastructure and that led me to the politics behind why countries go into outer

I don't believe we should just accept things as being inevitable. Do we for example have the right to be colonising other planets?

Space and then I became interested in the ethics of it all, which is a bit unusual for most people in my field.

Does a conversation about ethics throw things off?

Most people assume that it is just a done deal. Once the technology is there, then the colonisation, exploration and exploitation follows along with it, but as in other areas of terrestrial politics I don't believe we should just accept things as being inevitable. Do we for example have the *right* to be colonising other planets? I guess there is always an inherent sense of push back in me when we act deterministically, as if it is completely *natural* for us to go there.

Is there a contradiction between working within the field and pushing back on it?

Well, if I were to undermine it completely I would not have a career, right?

It seems like a very productive way forward, being part of and forming it with an inherently critical perspective.

You said it better than I have. There has to be a discussion. Frequently in public forums people refer to me as a devil's advocate or a killjoy. Because people come to these events and they want to hear about how romantic Space exploration is and that it is the destiny of mankind.

I am more attracted to the pragmatism of it all.

I am hesitant about exploration but I ultimately do believe that standard Space programmes have a very practical pay off. Using GPS to monitor your agriculture is a very obvious reason why you would want to have a Space infrastructure.

Having access to a communications network in Space is just like building a highway system today. But the exploration of distant planets is on a different scale of ambition and purpose altogether.

Different counties have different narratives about why they pursue the more *vanity* side of Space activity, but at the heart of it are power and prestige, the subtext being military capability. So that spending is more subject to criticism.

How can you practice your beliefs?

I bring about a counter-narrative, trying to get people to challenge the dominant narratives and to question where they come from.

I am not a qualified lawyer and I am not a full time philosopher. I have found this middle ground and for that reason, I fit most obviously within academia. I did my PhD and my Master's degree in International Political Theory at the London School of Economics where I have been for 16 years now. There is no obvious application for what I do.

But it's a very sexy subject that a lot of people want to be part of.

Space is a force multiplier that gives us the abilities to dominate in a military complex. People are interested in life and death and peace and war, so it taps into both sides of those extremes within each of our own psyches. That very peaceful collective humanity: *Where is our future? Where do we come from?* But it is also about the military high ground, the power-specific geopolitical military side of humanity. There is also a geographical element of it.

Space is at least *theoretically* open to everybody everywhere.

If you look at articles in double blind peer-reviewed academic journals that are co-authored by two people from different countries, the number one international discipline is Space Science. That is partly because you need to be able to see different sides of the sky at night.

So for practical reasons it brings people together.

One of the things I have looked at in my research is the ways in which individuals on the ground who network outside of political boundaries over time tend to be restricted within political spaces by countries that impose their funding regulations. So there is tension between different communities who are interested in Space while between individuals there tends to be a great willingness to network.

When I walked into my first Space industry conference three years ago, I didn't expect very much would be available to me as an artist. It was divided into *Military Day*, which was all about national interests, advancing our technologies of vision and the powers of looking and *Civilian Day*, which was about participation and the future of Spaceports: should they be lavishly designed by *Starchitects* to attracts VIPs or can they be done on the cheap out of a cardboard box? *Technology Day* was about small entrepreneurs developing *cubesats*, and by day four, when I had attended every single talk and absorbed every word, the *Disaster* panel came on and this insurance guy spoke about signing satellite policies worth millions with a handshake because, *How else could you check on the wreckage?* It ran on trust and I was sold.

For my PhD I looked at why, given that international law technically doesn't have an inherent enforcement mechanism, do different countries adhere to the agreements that we come up with? Trust is a nice way of putting it. I traced it back to concern about being seen as credible. I mean, you have rogue actors but for the most part people want to fit within the social context in which they've embedded themselves, and be legitimate.

There is no Space police, Space court or jail up there for Space law offenders?

No, technically it is all brokered through the United Nations' office of Outer Space Affairs but realistically, if there is an accident it would be the insurance companies battling it out. But in terms of agreeing not to put certain weapons in Space – because if you do it then other people can do it too – you simply don't want to be seen as violating the agreement. I know it sounds a bit fluffy, but generally I do think it holds some clout within behaviour amongst countries, which means behaviour amongst individuals.

You are deeply invested. Can you point to a situation and say you have affected an outcome?

No, and I think the older I get the more I realise that you are just a very small part of a much more complicated picture. If anything, I bring about a counter-narrative, trying to get people to challenge the dominant narratives and to question where they come from, *Can we just step back and take a look at the assumption that we have a natural right to colonise?* It is a discussion that tends to be missing on panels and Space conferences because people who go into the discipline tend to naturally be pro-colonisation.

And questioning is seen as being *against*?

Well, for example, I brought up as part of a wider press conference the issue of what messages we are sending into outer Space about ourselves. Oh god, it was a shit-storm.

Okay so tell me about this shit-storm.

I have always been interested in the search for extra-terrestrial intelligence, but from a more practical side, because I am not a big science-fiction person. It is interesting to listen, but more interesting is thinking through the scenarios, if we were to be contacted what

would happen? And when we send messages out, how do we want to represent ourselves? We look out in order to look in. And the looking in is what is interesting to me. We search the Universe to find ourselves.

Has that always been obvious to you?

I don't want to sound arrogant but yes. The first time I was asked to speak at the SETI Institute in Mountain View, California I said more or less that. I was met with such a hostile audience, way more emotive about the issue than I had ever realised. People believing that we shouldn't be trying to contact anybody, or arguing about controlling what we say about ourselves. I was much more liberal in my approach.

So in that case, you were the one pushing the agenda?

I suppose, yes.

And your audience was reacting against it.

I thought it was a fairly benign presentation and so intellectually, I walked away. SETI stands for the *Search for Extra-Terrestrial Intelligence*: if you just have a telescope or radio and you listen at night then you are doing SETI. Recently, there has been a big break within the community between those who think we should just do passive SETI, which is listening, and those who think we should do active SETI or METI (Messaging Extra-Terrestrial Intelligence).

I have since become involved in this new organisation, METI that is proactive about sending messages out and thinking scientifically about how inter-species communication works. What would we need to say in order to be understood? And philosophically, what do we want to say about ourselves.

Okay.

So we advocate sending messages out. It is quite emotive when this gets discussed at academic meetings. People who are against it think that if we encounter extra-terrestrial intelligence they are likely to be hostile. We have been leaking information about ourselves for 60 or 70 years via telecommunications. Some people go so far as to say we should put an electro-magnetic cap on the planet and stop any more information. It is called *hiding under a rock*, to keep us safe. And then on the other end of the spectrum you have people like myself who think we should actually try to send messages out, just because it is interesting.

So you are not necessarily into meeting someone, you are interested in reflecting ourselves in those actions? That is what I am mostly interested in. It is a very different philosophical position.

I hadn't said that. I think if we did encounter them, people automatically assume that they would want to

Isn't it arrogant to assume that we are the only creatures in this universe to evolve. Why do we think we are so special?

kill us. I think if they have survived long enough to have the technological capability to contact us they might actually be able to help us. I think we have a good chance of destroying ourselves and they might know how to fix climate change, for example.

Isn't this science-fiction, what we are talking about right now? Both positions?

I take your point. It is a bit more on the science-fiction realm than what I usually do. I am usually much more focused on quotidian Space activities.

Up until a certain moment I completely dismissed the idea of aliens. Then I heard about the Drake equation and about exoplanets. We have mapped the Universe enough to know that there are basic *conditions* for life on other planets and we know that these planets exist. This turns fantasies into statistical probabilities.

The Drake equation is a scientific model that talks about life on other planets statistically, as in *likelihood*. I think that in the space and the time of the Universe, the likelihood of us evolving concomitantly and managing to have the technology to contact each other is not going to happen. But isn't it arrogant to assume that we are the only creatures in this universe to evolve? Why do we think we are so special?

As long as the question remains open, it spurs the search, the speculations and the controversies. We need to keep asking, *Are We Alone in the Universe?* because the potential for the affirmative *NO* is there. If the question was answered with a negative, *YES, We Are Alone in the Universe*, we might have to face being lonely with each other after all. I made that drawing as well.

So in all of that much more complicated context, I was at a press conference and I mentioned the Voyager plaques and how the human figures were represented. A lot of people have discussed them over the years. I was quoted as saying, *The male figure has his hand up and looks dominant and the female figure is in the background looking passive*. The *Daily Mail* picked it up and ran with this political correctness for aliens thing. For the first time ever I was trolled and got physical hate mail, death threats and rape threats sent to me online.

But the raised hand, that is one of the oldest arguments... the only shocking thing about it is you getting rape threats. *That* is new!

Thank you. I wasn't ranting and raving, I was just saying what I thought. I managed to go on the BBC World Service and clarify that I was also talking about the way we represent our anatomy, our joints, also the genitalia were controversial. If we are going to put out two figures, how much detail do we give about ourselves? I just think it is a fascinating question.

Is there any answer to that question forming among your peers and the public, or just hate?

I don't feel like there is a dominant narrative that is emerging yet. I think the biggest question that people seize upon is, *Do we whitewash our history? Do we only send them a specific narrative?* This is assuming A) it'll be intercepted and B) they would understand what the hell we were trying to say. Again, to me it is more about how we think about ourselves. Do we present a picture of ourselves or do we just send them everything? I personally think we should just send them everything.

> # Do we present a picture of ourselves or do we just send them everything?

What defines *everything* and how is it contained? The Internet in a package, every book ever written, or a chip out of my brain? What is the sum of human existence?

You have just commissioned yourself to come present at one of our events.

Well, I have been experimenting with an answer for a message to send.

Great, tell me.

First, I don't have a very discerning way of looking at this information so, somewhere between the academic talks and through the trashy press, I heard about this intention to send out messages. I went to a conference at the Science Museum organised by the European Space Agency on *Inspiration. Breakthrough Initiatives* who have an open call and are giving out a $1,000,000 prize for the best message, presented their technology, a field of lasers and a *micro-miniaturised* electronic chip. The funniest thing was that when they showed us the micro-miniaturised chip, it was projected on a gigantic slide, maybe five by five meters across!

METI consciously decided not to follow the Breakthrough Initiatives just because it would have meant focusing our efforts on one message, as opposed to going where we think we are best placed, which is to survey the academic community about the best way to construct the message, and to ask the wider public about what we should be sending. We are seeking to bring in a larger number of voices from around the world so it is not just an Anglophile discussion.

You are leaning towards a diversity of messages?

I am, personally. On our board we have anthropologists, an Interspecies Communications specialist, a ballerina and myself as a Philosophy-Lawyer. Some people have a much more technical approach and want to talk about the use of code or engineering drawings. Other people say, *Maybe we should send music and if we are going to send music what kind of music do we send?* But collectively, I think we are committed to a more all-encompassing diverse representation of who we are.

I posed the question as an artistic problem and came up with the perfect answer for a message.

What? What would you say?

It would be this drawing here.

SORRY?

If we prefaced all of our encounters with an apology it would mitigate future drama. Even in the most loving relationships people step on each others' toes. If we are at that point unable to express an apology, either for whom we are or for what we have done, or for our assumptions about each other, that is where the trouble starts. So my message is to say SORRY for everything, and up front. Sorry to bother you first of all!

You should enter it in the Breakthrough Initiatives.

I think I will. The reason why I designed it like a big cartoonish gag is because I am throwing it out there as a joke. You can laugh it off, or take it as seriously as you want.

METI wants to make sure that a message can be interpreted scientifically while Breakthrough are looking for one hook, whether it is a school child who draws a flower or something ironic. One of the things we have talked about is how to project humour.

Humour is a sign of our level of intelligence. It lets us think and communicate in layers, use contradiction, nuance and metaphor that can unlock vast complexities in an instant. Yet, jokes typically don't work in emails. So how will they work in Outer Space? Do I say *Ha, Ha, Ha* afterwards? Or do I put my message in quotation marks or send a farting sound to go with it? I am actually not joking.

Again, something like this is more about what we are saying about ourselves than what we are actually saying to them, potentially. How long have you been working on this?

My whole lifetime, but technically speaking we made this drawing fairly quickly because it is such a simple design. But again, if you look at the strokes you can see that there are ten people's hands in them.

I see yes, because they are in slightly different styles.

Because the drawings are so big I need multiple hands and so I run these workshops with groups of students and young artists. They help with anything from filling in outlines to experimenting with ideas, and the result is richer than anything I could have achieved by myself. We already worked through the Pioneer plaque last year. I ran a workshop here in the studio where we reworked those figures in different ways.

Oh did you? You are joking, you did?

I photocopied the original line drawings and I gave the group pens, scissors, cutting boards, paper and glue sticks. I told them about the plaque: *If you were asked to re-design a presentation of the two figures and you had this as a reference that you thought you could improve on or update to best represent humanity today, what would you do?*

So exciting. I actually feel a bit emotional.

Why?

Because those figures have been so central to things I have been through. How many people were there and how old were they?

There were 12 last year. 18 to 25 years old. The way I work with young people is that I ask them to respond to my simple problems in a very personal way. It is a very casual give and take between us. They get paid work experience with a senior artist and insight into how studios and institutions work, while I need help and am interested in diversifying my own hand and thought process. Ten people are always going have a more diverse response than one.

Right, okay.

I have been told by experts that this is an extremely limiting way of analysing the original plaque. That the figures exist as part of the bigger design and that there is so much more to say about it. But for my purposes, the figure is central to human self-representation and it is central to art history. So we looked purely at the bodies and played around with lots of ideas, hundreds. You can re-create this exercise with anyone and anywhere.

One of the things we have talked about is how to project humour.

I can't believe you did all this. This is perfect.

Artists have been reworking those figures since they first came out; my favourite is Jack Kirby's superhero version. He was commissioned by the *LA Times* that did a whole artists special on them in 1972. Of course fantasy artists can do whatever they want. But I wanted my group of students to rework the original, to stay close to the source.

Why?

Most artists today, myself included – I studied at the School of Visual Arts in NYC in the '90s and the young people who come through my studio are University Arts London graduates – are the products of what is referred to as a *de-skilled* art education. Most western art academies have done away with the classical anatomical study of the human body by now. So there is already a generational divide between Linda Salzman Sagan who drew the Pioneer couple and my crew. Never mind the controversies around genitals or ethnocentric facial features, we wouldn't even know how to draw an anatomically correct leg today. Not that there is much of a reason to do that either. We can use photography to convey the naturalism and when it comes to the ideal body, well, everything is up for grabs.

Body modification and extreme exercise routines are rampant while the body-positive movement celebrates being fat and heteronormativity is over. How can you even start representing humanity with two ideal figures when the whole concept of *one ideal* is obsolete?

I have never even thought about that. That traditional art education has a lot to do with how those figures look.

London art students come from all over the world. I will occasionally have a student from Romania or Spain where they are still rigorously trained in the classic tradition, but if they show up here in my studio, they are at a stage in their life where they want to abandon all that and do graffiti or conceptual text work instead. So even if they *could* draw that way, they no longer *want* to because they don't think it is relevant or cool enough!

Then you have some established artists *returning* to classical skills, only to use them ironically. But how do you convey irony when you lack the context or reference? These messages are rather pointless outside their original context, Earth.

That is fascinating.

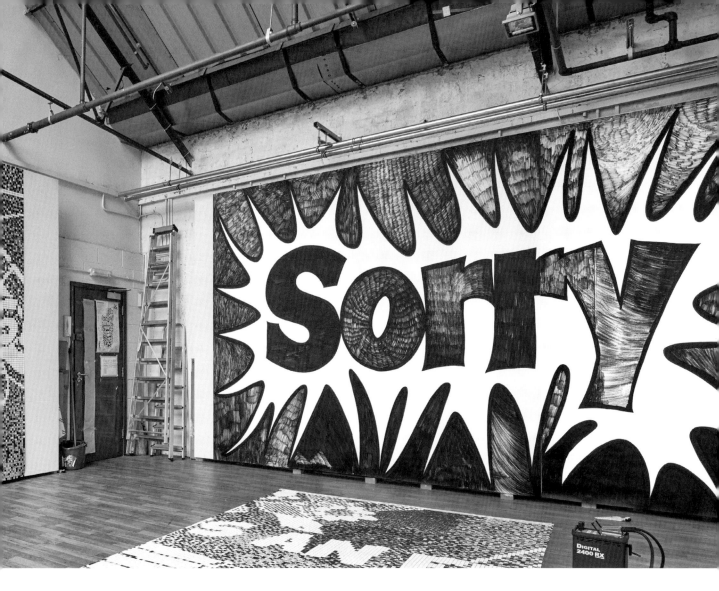

Aleksandra Mir
SORRY
fibre-tipped pen on synthetic canvas
300x600 cm, 2015–17

In the workshop we used commonplace artistic strategies like collage or appropriation, the idea being that it is okay to rework images that already exist in abundance in the public domain, to comment on them, dissect previous ideals and give them new meaning. So we are quoting, cutting and pasting and moving Linda's work around until it suits our contemporary purpose. We give homage and scrutinise in one go.

What role do you then play?

I am the author of the exercise, I fundraise and manage all the logistics to create the most conducive environment for experimentation, and I edit what I find most revealing and interesting at the end. Anyone can do this at home but given the diversity here, the variation between people's backgrounds and motivations and the variation of energies over the course of the day, I think my workshop creates a playful conversation rather than more dogma, right?

Yes, absolutely.

None of these ideas are an absolute or the absolute best. They are just versions of events, the results of the circumstances of that day and, as a survey, possibly a reflection of what young people might think is relevant right now. I have no way of knowing if they respond to my question sincerely or ironically.

How far from Hackney is Jupiter?

How far from Canary Wharf

How far from Brom

How far from Brom

If you whiz around long enough, you will collide with something

STUART EVES is one of a growing band of Space scientists who are developing the concept of Space Traffic Control, and is the author of a recent book on the subject. Stuart works for Surrey Satellite Technology Limited, in Guildford, UK.

Aleksandra Mir
SOLAR SYSTEM
(pages 82–95)
fibre-tipped pen on synthetic canvas
300×400 cm each, 2015–17

Librarian Sian Prosser with Stuart Eves
Royal Astronomical Society, London

ALEKSANDRA: I came in on the tube from Bethnal Green to meet you this morning and the crowded journey made the distance highly tangible, *Are we there yet?* But now we sit here in the library at the Royal Astronomical Society, which is the epicentre of knowledge about vast distances, and yet we still do not have any better *sense* of them. You have told me about the problem of conveying the idea of astronomical distances to your students.

STUART: We spend some time out in the playing field at the school where I teach in Newbury, where I take the students out on a sunny day and have them pace across the running track in the hope of giving them some sense of scale. When we go out in the field, I ask them to reduce the scale of the Universe by a series of factors. At a scale reduction of 10 to the power of seven, the Earth is the size of a marble, the Sun is a beach ball and we can fit the distance between them into the playing field: and by the time we get down to a scale factor of 10 to the power of 24 the entire visible Universe will fit in our playing field, sort of.

When the *Light Year* unit was invented we were able to slash 11 zeros from previous cumbersome measurements, but we still can't really fathom what it is. Humanity is now out there, looking at, measuring and sending things out to Space. Even if our bodies have not met the criteria yet, we can place ourselves there with technology, via instruments and calculations, even virtual reality gadgets, but for the most part, these are abstractions and I am curious of how to bridge that gap and make these distances tangible.

It is very difficult, isn't it? Because we can talk about something being four light years away but we are not photons and we don't travel at the speed of light. A photon might know what four light years feels or looks like. We certainly don't. You can draw a little diagram that shows the Sun and plot the positions of stars. The trouble is that if you want to show the Sun as a visible object, the distances to the nearest stars are so big that you would find it very, very difficult to draw any sort of map.

No size of paper can hold that drawing accurately.

The accurate visual representation of these distances on a piece of paper will only work if you scale down the Sun so much that it becomes microscopic, until you can't even see it. That's part of the problem.

That make this whole sphere of knowledge only really accessible to the expertise that works with its numbers, and is content doing just that, but without actually *sensing* it.

Well, the reason that I tried using that analogy for my school kids is because you can just wave numbers like 10 to the power of 24, and it has little, if any meaning at all for them. I felt that if I did it in stages they might at least get some sort of an appreciation of just what a big universe we live in.

So it is very useful I think, even as adults, to embody distance, any distance, and to think about this in relation to Space. Our first conversation has manifested itself in a set of drawings where I represent various locations in the vicinity of my studio that I can access by walking and cycling. I map that experience onto the Solar System in a series of ridiculous questions that collapse local and cosmic distances. The poetics and absurdity is simply meant to jolt you into the subject in an open ended way. But then I had a scientist friend, Clara Sousa-Silva, who works on exoplanets come into the studio and she knew the exact answer!

I fully appreciate that this is *art* and so does not need to be either A) explained, or B) representational of reality.

This project is very much based on research. It both references and produces reality, but certainly no fixed answers. Here are some drawings of the *International Space Station*. I have never seen it, but its existence has been made tangible to myself and my team by making these drawings. Drawing is a form of embodiment, not unlike physical travel.

A question, though, prompted in part by the fact that you have accurately captured the ageing, or warping effects on the Space station solar arrays.

I didn't know I was doing this! Please explain what you see.

These are some of the solar arrays on the station. When launched, they wouldn't have had gaps between them but they would be geometrically aligned. They work most efficiently this way as when they are steered to point at the Sun, the maximum area is presented for power generation. But the Space environment is harsh. Over time, thermal cycling, radiation damage, and the effects of atomic oxygen degrade the materials in the arrays, and they warp. So what you have captured in your art is a *mature* Space station, with evidence of ageing, rather than one in the first flush of youth. The

> *What you have captured in your art is a mature space station, with evidence of ageing, rather than one in the first flush of youth.*

arrays also suffer damage due to micrometeorite and Space debris impacts. This is small-scale damage which wouldn't often be visible in the images you have, but generally leads to arrays looking rather tatty over time, rather like most biological systems!

I had no idea. The disintegration you describe I simply registered as an organic quality of something otherwise static. It all makes sense now. The idea that technology has a life curve, like any organic body, is what these drawings are about. When you design and build satellites, you must already be aware of their lifespan and how they will behave as they age?

The concept of a *satellite design lifetime* is very well established. Ours are typically five to seven years. Space stations are typically expected to last longer, but then they have the possibility of repair and maintenance.

In defining what you do at your job, one of the words that came up was *Inventor*.

Well, *Ideas guy*.

If you could leave humility aside, what could you sign your name on and say, *I have advanced this.*

The standard imaging satellite points a telescope down towards the ground and takes pictures. It is travelling across the ground at the speed of seven kilometres a second – or extremely fast – and it doesn't stay over any given point for very long. The innovation I conceived for the *TopSat* mission in 2005 was that instead of staring straight down, we would look a bit forward towards the thing we wanted to take a picture of, and deliberately pitch the spacecraft backwards so that the pitching motion slowed the sensor across the ground. It took pictures with a resolution of about two and a half metres, which at the time was a world record. The engineering model was put on display in the Science Museum while the real one was in orbit taking pictures. That was quite nice. It created a new evolutionary path for the spacecraft that has enabled a lot of spinoffs.

You have recently written a book about Space debris. So on one hand you are an inventor thinking about future technology but you are also an expert on its final end.

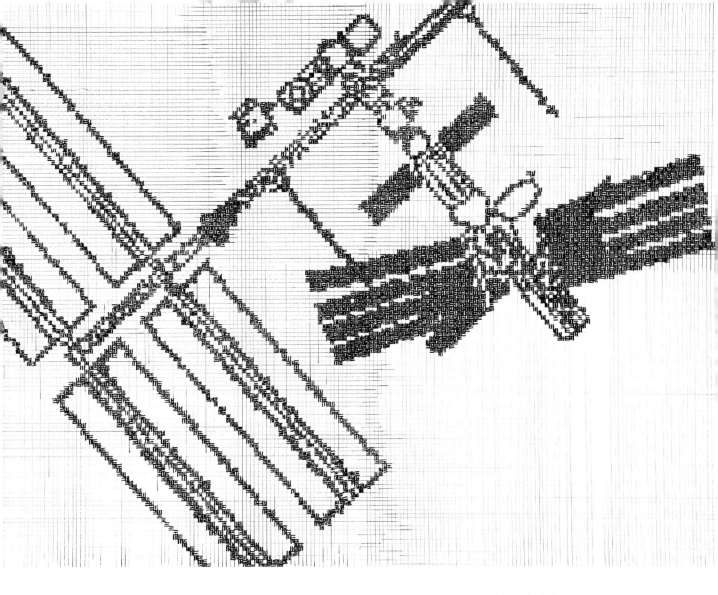

Aleksandra Mir
INTERNATIONAL SPACE STATION
fibre-tipped pen on paper
70x100 cm, 2015–17

Something like 7,000 tonnes of material have been launched and a large percentage is still up there.

You are there at the birth, and at the funeral. You are looking at a whole arc of the lifecycle of a spacecraft.

Yeah. End to end.

Is that a novel way of thinking about technology?

It is a better way than perhaps we had in the past with the ruins of the industrial revolution where people created things and didn't think about how they would dispose of them. In some cases, the old steam engines for example, that were made of valuable materials, it was worth cutting them up for scrap and recycling them. But historically in the Space realm, it was almost impossible to do any form of useful recycling. People put stuff up there, and then just allowed it to fail.

Was that out of genuine ignorance, because there was simply no sense of future consequence, or was it a calculated, consumerist approach to stuff?

Possibly a bit of both. The most practical way of dealing with stuff historically would have been to save some propellant on the spacecraft, and make a manoeuvre at the end of its useful life that would bring it back down towards the atmosphere, where it would burn up and turn into atoms. But the very largest things, like Space stations, some parts of them might actually survive to the ground.

When the Russians de-orbited the *Salyut* 7 Space station in the early 1990s, there was a total of about 40 tonnes heading back towards the Earth! They were aiming it at the Pacific, which is a very big ocean, but actually dropped debris on the border between Chile and Argentina, which would suggest that they didn't actually have the level of control they were claiming at the time. The US had the same sort of issue with the *Skylab* Space station. They tried to de-orbit it into the Indian Ocean, and they missed too. Some of it landed in the ocean off Perth and some of it ended up in the Australian desert.

Apart from those things that are coming down, there is still a lot up there.

The estimates vary, but something like 7,000 tonnes of material have been launched and a large percentage is still up there. A lot of it is still in discreet lumps like satellites or the rocket bodies that delivered them there. The concern is that just by the laws of statistics, if you whiz around in orbit for long enough, you will eventually collide with something, and really fast. The things that do collide tend to turn into thousands of tiny fragments, and that is where it becomes difficult, because essentially these are projectiles, many thousands in number, whizzing around in low Earth orbit with considerably greater kinetic energy than a rifle bullet, potentially at risk of hitting other functioning satellites.

> *The time to act is now before the situation gets worse, because if we leave the stuff up there, eventually, things will start colliding with one another.*

Any environmentalist would find it appalling, but this has now become a problem for the industry itself.

It is a rather curious situation because when people started launching stuff into Space, most of the Space operations were conducted by nations. In the 1960s it was very much about national prestige. Then, gradually over the last 10–20 years we have a much greater preponderance of commercial activities in Space. The difficulty that we face is that a lot of the junk that's up there is old national satellites. The commercial sector, which wants to do business in Earth orbit, is looking at the debris situation thinking that we need to do something about it.

The industry is concerned with the future ecology of its orbits or they soon won't be accessible anymore.

Yes, indeed so. But trying to clean up Space debris requires a mission in its own right. That is expensive and who is going to pay for that? It has been suggested that people from commercial companies applying for launch licenses should pay a levy to a fund that would be used to do the debris cleanup. That is not very popular because for a start, raising the finance to do a satellite mission is not always easy. If you had to raise even more money to pay this levy, you might decide not to do it at all.

That is like me being a first time driver having to pay for my grandfather's sins.

Not unreasonably I think. You can go back to the nations who put it there and ask them to clean it up. You can

> *Going back in time they didn't really quite grasp the potential severity of the debris problem. Satellites would go up, and they would ping off bits.*

go to the United Nations, and present a resolution that says, *We recognise this problem in the low Earth orbit, thou shalt go into low Earth orbit and clear up the mess you've made.* Unfortunately, it would require many more rockets, and some technology that doesn't exist at the moment, to safely capture and de-orbit stuff. Things don't just sit in Space benignly, they are almost certainly tumbling, and if you think about the challenge of grappling something that's tumbling end-over-end at seven and a half kilometres a second…

That is like trying to cleanup the inside of a tornado while it is spinning!

It's really hard. I mean, you can deal with the relative velocity, like getting cars going the same speed on a motorway. Then there are various suggestions, harpoons, nets, grappling arms. All of them are really quite difficult and expensive to do. The chances that you present this motion at the United Nations and the US and Russia would vote for it, I think is pretty much zero. It would be one of the rare occasions when the US and Russia actually voted on the same side of an issue at the United Nations, and they would both say, *No, we can't afford to go and clean up the mess.* At which point then we really do face quite a challenge.

The consequence of failing that is that you are going to clog up an orbit and you can't be there anymore?

That's right.

Space is big. Does it matter?

It does. The orbits that will get clogged up are the useful ones that are comparatively close to the Earth. Yes, in theory you can go to a higher orbit further away from the Earth. So if you are trying to provide a communications service, you now have to transmit more power, the satellite has to be bigger, the rocket that carries them higher also has to be bigger. If you are taking pictures of the Earth, you are now further away so you need a bigger telescope in order to get the same quality of images, so everything needs to get bigger.

The time to act is now, before the situation gets worse, because if we leave the stuff up there, eventually, things will start colliding with one another and you get this cascade effect. It is like the chain reaction in a nuclear reactor where one interaction happens, and a series of products from that interaction go off and create further

issues. All the fragments from one collision can potentially go off and collide with something else.

It is hard to accept the level of naiveté that brought us here, that engineers like yourself were unable to foresee this from the start?

Going back in time they didn't really quite grasp the potential severity of the debris problem. Satellites would go up, and they would ping off bits. For example, you tend to put a protective cover over your optics that you eventually want to get rid of to allow you to look out through your telescope. What we do now is we fold back such a cover on a hinge. Historically though, they would have a spring-loaded cover, and it would just pop off.

In the end, we had to cross our fingers and hope.

There goes my lens cap, off into Space. Goodbye forever.

We figured that that was a bad thing about 20 years ago. We did actually start mandating that you shouldn't just pop off random bits of debris. People seemed to start getting that idea.

Which corresponds to a general consciousness about the environment, but there are already thousands of bits up there. What are they though? They can't be all pinged off lens caps?

I think the official catalogue is 23,000 objects that we can track, and then some other stuff that is tracked but remains unpublished, because it is military technology. So a lot of the bigger objects are complete satellites or the rocket bodies that launched them, but then there are also fragments from a couple of *celebrated* collisions that have occurred, where things have collided and created a lot of shrapnel.

What is a celebrated collision?

In 2009, there was an unintended collision between an active American communication satellite and a Russian cosmos satellite that created some 3,000 bits. Two years earlier, in 2007, the Chinese decided to demonstrate that they had a weapon capability, so they fired a missile at one of their old, redundant satellites. It blew it into about two and half thousand pieces I think. Ironically, there was an international debris mitigation meeting happening at the time. Some members of the Chinese government who knew nothing about this planned test were attending that meeting, while some members of the People's Liberation Army in China decided to conduct the test without, apparently, consulting with their diplomats representing China.

The anti-satellite weapon test happened, and the Chinese delegation were running around going, *What the hell happened?* I felt rather sorry for the Chinese delegation that were at the meeting, because it would appear that they were deliberately not informed. That is not entirely surprising. Lots of military forces like to have secrets. They don't want to tell the opposition what their capabilities are.

There are gatherings where these things are peacefully discussed?

The Inter Agency Debris Committee, IADC. There is also a United Nations body called the Committee for the Peaceful Uses of Outer Space, which has a very contorted acronym, COPUOS.

Blowing something up is a very graphic, visually and metaphorically powerful manifestation suited for cartoons and cinema. But it seems entirely counter-productive if you are planning to launch more of your own stuff, and your own people eventually, that you aim at keeping safe.

Blowing a satellite to smithereens with a missile is about as in-your-face-in-outer-Space as it gets. There are more subtle ways by which one could achieve the same effect. There is a lot of talk about hacking, and cyber threats these days. Conceivably at least, you could send out a bunch of unauthorised radio commands that said, *Please switch off.* You might not even have to do permanent damage, you might just create a reversible effect that takes the opposition a period of time to deal with the problem. Perhaps it would take a week or two to figure out what happened and in that time, maybe all the important stuff in a conflict happens, and by the time they have got the satellite back up and running again, it is too late.

This is obvious to the current generation. When we came to visit you at work, I brought two of my art assistants who have zero knowledge of Space technology and we were all very impressed with your mission control room. One of the girls asked right away, *How do you not get hacked?*

I told her, *This room is not connected to the Internet!*

And that really resonates with everyone today. You wanna keep anything safe or private? Get offline! What other preventive measures can you take?

My company makes a virtue of trying to be relatively low cost, the laptops of Space if you like. We still think it is a jolly bad idea when we get what is called a *Conjunction Warning* where orbits are predicted forward, and it says, *In five days' time, your satellite is going to get awfully close to that piece of Space debris; What are you going to do about it?* Well, we are not going to just sit there and ignore it. If we have enough information to make a

sensible manoeuvre that will reduce the probability of a collision, we will do that.

Everything is tracked, assessed and navigated around?

There are various organisations. The JSpOC (Joint Space Operations Centre in the United States) have got a bunch of radar and other telescope sensors that they use to track stuff. They calculate the orbits, and run it through a big computer program to simulate what potentially gets too close to what. If they see an active satellite getting close to a piece of debris, they will issue a warning.

Does it work?

Sometimes you find that the tracking actually isn't that good. The last time my company had a conjunction we originally thought we were going to have a miss-distance measured in kilometres, but the last message we got suddenly took the potential probability of collision much, much higher, because the estimated miss-distance was something like 200 metres. By that point, there was about six hours to go before the two things were going to potentially collide, and we didn't have the time to calculate a sensible manoeuvre. In some cases you have to first warm up the propulsion system and we just didn't have time for that whole process. There was also a significant chance that if we did things in a rush we might make a mistake and actually move towards the debris rather than away from it. In the end, we had to cross our fingers and hope.

Faith in this context truly sounds like a last resort.

We could do better tracking to predict the orbits with a higher degree of confidence and further into the future. That is part of the hypothesis of my book, that there are things we can do to make the whole process better.

It also comes with the pressure of the insurance industry. I went to one of those presentations on Space insurance, and the guy was talking about it in terms of car insurance, *It works the same way, the only difference is you can't go and check on the wreckage.* **So the arrangements are done by handshake agreements and trust. Is it really like that?**

It is most of the time.

The sizes of the premiums are immense and the agreement is almost banal, but it directly affects the reality of the job you do. If you don't get insurance, you can't do anything.

Exactly. I have been most impressed by the insurance industry's level of detail that they will go to, to make sure that they are setting appropriate premiums, and actually calculating the probabilities accurately. In the case of satellite designs for example, if they are asked to ensure against a random failure on the satellite, they

> *If something the size of a sugar cube crashes into your satellite you'll know that something bad has happened, but you won't know what hit you because you weren't tracking something that small.*

will look very closely, right down at the low level of circuit diagrams to check what components are being used, and whether those components have a track record of working successfully in Space. Some microelectronics really don't like being put in a vacuum, or in a radiation environment. The insurers work at huge levels of detail there. The problem that the insurance industry has is that they just don't know what the probabilities of being hit are.

You can't really prove what has happened.

You can't prove it anyway. The current tracking systems are advertised to get down to objects about 10 cm in size. So if something the size of a sugar cube crashes into your satellite and hits its fuel tank, and it breaks up, you'll see the fragments coming off, and you'll know that something bad has happened, but you won't know what hit you because you weren't tracking something that small.

So things could eventually come to a halt?

Yeah. It's called the *Kessler syndrome*, named after the American mathematician who originally did some of the calculations. The bottom line is, if you get above a certain density of stuff distributed in a particular orbit altitude, and if you launch something to that altitude it will inevitability get hit at some point, and then turn into more pieces of debris which will then accelerate the growth of the debris population. You cross a particular density threshold, and then the thing just accelerates away; eventually you just grind up all the bits in the orbit.

Studio Assistants Moira Lam and Yasmin Falahat visit with Stuart Eves
Surrey Satellite Technology LTD,
Guildford, 2016

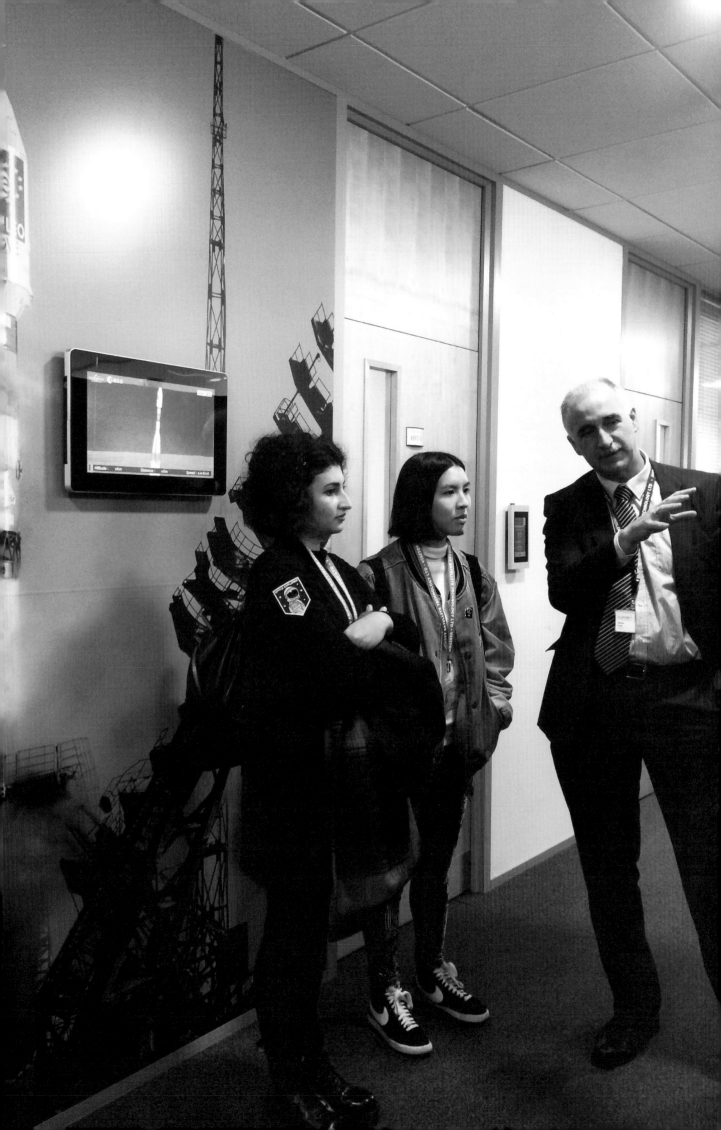

We are all stakeholders in what happens to the Moon

ALICE GORMAN is a pioneer in the emerging field of Space archaeology and heritage. She specialises in orbital debris, tracking stations and terrestrial launch sites. Alice is based at the Department of Archaeology, Flinders University, Adelaide, Australia.

Aleksandra Mir
SATELLITE PORTO ALEGRE
Produced by the 9th Bienal do Mercosul,
Porto Alegre, Brazil, 2013

ALEKSANDRA: As an Australian archaeologist your early work was on ancient Aboriginal culture. What made you look at the much more recent history of Space exploration and the artefacts this culture has created and left behind?

ALICE: While many people think of archaeology as the study of ancient things, it is really more a set of theories and methods which can be applied to any material culture, no matter how old it is, or where it is. My first career was as a heritage consultant, where I had to ensure that developers, such as mining companies, complied with legislation aimed at protecting Aboriginal cultural heritage. This meant working closely with Aboriginal communities. In this environment, you really can't think of the past as something distant in time, as it is central to how Aboriginal people have to negotiate their existence every day. Often you are out in the field with Elders, and a place where you find archaeological evidence of a 6,000 year old camp site is where they went fishing with their parents and where they take their own kids fishing. The past is really in the present – as it is for all of us. From this perspective, it is not such a leap to start thinking about places and objects in the more recent era of Space exploration as archaeology.

Having said that, for me Space archaeology really came as a revelation – I had a thought like a bolt from the blue about 13 years ago, and I was hooked. My background did, however, very much inform my approach. One of the first things I did was to start looking at the Woomera Rocket Range in South Australia. This was one of the early Cold War rocket launch sites, established in 1947. It was natural for me to ask what was happening to the *Traditional Owners* while Australia and the UK were busy designing nuclear missiles and upper atmosphere research rockets on their country. Since then I have woven Indigenous issues into all my research.

This led me to investigate the two pieces of Aboriginal music on the Voyager golden records – discovering in the process who the artists were, and that Carl Sagan and his team had made a mistake in the documentation about the names of the songs. I started thinking about what it meant to translate Aboriginal culture into Space. I can't speak for Aboriginal groups, but at least I can

find out what the back story is. I'd written a bit about place names in Space, and when I was invited to give a talk to the Australian Place Names Symposium in 2015, I used the opportunity to map Aboriginal words used for planetary features. It turns out to be 0.3% of all the named non-Earth locations in the Solar System, with some names representing major mythological landscapes. This has implications as it extends the Aboriginal landscapes, and perhaps the cultural responsibilities that go with them, into Space.

You are closely following and reporting on the legislation of Space, arguing that the earliest sites of human landing on the Moon deserve protection. What are they threatened by and how would you like to see them preserved and accessed in the future?

The sites need protection from human activity. We can't control the natural environment on the Moon – the flags, landing modules and other artefacts left behind are going to slowly decay over hundreds or thousands of years anyway. What we can control is the decisions we make about future activities on the Moon and what is important to us. My argument is very simple really: why destroy something if we don't have to, and if it costs nothing to preserve it?

Once upon a time, the Apollo human landing sites, and all the robotic Lunas, Rangers, Surveyors etc were protected by their remoteness. People used to talk about Space tourism, and the sorts of dangers we see at heritage sites on Earth – vandalism, souveniring, and just plain bad behaviour – but this was a far-off scenario. Then there was the Google Lunar XPrize, which originally proposed that participants bring back a piece of an Apollo site, inevitably destroying its integrity in the process. At the moment the teams get a bonus for filming at one of the Apollo sites. Better, but still potentially damaging. It is frustrating that despite making a big deal about the heritage, neither the Lunar XPrize nor any of the teams have sought expert heritage advice and are quite resistant to approaches.

In the last few years we have seen discussions around lunar mining and resource use really accelerate. As with destructive mining operations the world over, the sniff of profit eclipses all other considerations. This is where I apply my experience from my former career. On Earth, mining companies have to go through an environmental impact process which takes into account social values like heritage. It is a flawed process that often doesn't work as well as you would like it to, but it makes mining companies accountable. I think we really need this process on the Moon. This means a proposal would have to look at location, methods of transport, exploration techniques, mining and mineral processing methods and habitation requirements, and work out what the impacts on lunar heritage sites would be. Based on this, they might change the location, build blast walls to contain dust, or consider different *beneficiation* methods. The key to this, as on Earth, is to do these studies at the pre-feasibility stage – not when

> *Think about how widespread the belief that the Moon landings never happened is – and think about what might happen if we actually destroyed the physical evidence that they did!*

you are about to land on the Moon and start building a moonport for the first freighters to arrive.

Think about how widespread the belief that the Moon landings never happened is — and think about what might happen if we actually destroyed the physical evidence that they did! The first step is to make sure that something survives for the future lunar tourist or researcher. I suspect that, with the way 3D modelling and virtual reality are developing on Earth in heritage contexts, we may end up making 3D immersive replicas, as has happened for the Palaeolithic rock art site of Chauvet Cave in France. The big issue here is *authenticity*, which is controversial enough on Earth. But let's cross that bridge when we get to it.

While Australia is not a Space faring nation, you argue it is still a *stakeholder* in lunar heritage.

In the narrative of the Space Race, I think people often forget just how much co-operation and collaboration in Space activities has gone on. I like to emphasise this as it gives me hope for the future! For example, Australia contributed a very important experiment to Apollo 11 and later Apollo missions. Professor Brian O'Brien thought that measuring dust on the Moon was going to be critical and so he persuaded NASA to take his dust experiment up. And he was absolutely right. Harrison Schmitt, the geologist who was on the Apollo 17 mission, said that dust is the number one concern in returning to the Moon. So here we have a very significant piece of science, but we also have Australian technological heritage – a matchbox-sized device still attached to one of the experiment packages at Tranquility Base. If, let's say, a Google LunarX participant decided to remove the experiment as a souvenir, then Australians would have a right be upset.

Apollo 11 is not a completely dead archaeological site – there is one experiment that's ongoing. The Lunar Laser Ranging Retroreflector is an instrument that the astronauts left behind so that scientists on Earth can bounce lasers off it, gathering all kinds of data from how long the laser beam takes to return. As part of this experiment, a laser ranging facility was built at the Orroral Valley NASA tracking station outside Canberra. It's no longer operational as the tracking station was decommissioned in 1985, but it directly connects Australia to Tranquility Base.

I am sure there are countless other examples of non-US contributions to the Apollo program. As the US claimed the Moon landings were on behalf of all humanity, I think we get to have a say in what happens to them!

I always felt like a stakeholder in lunar heritage myself. Isn't everyone a stakeholder by virtue of simply having the freedom to look at, enjoy and interpret the Moon?

Absolutely, and I think there are some worrying trends in recent dialogues about exploiting lunar resources, which completely overlook this. Mining and aerospace engineers don't think along these lines – it is not in their training. Whenever I have talked about the Moon as the common heritage of humanity to these sorts of audiences, it is clear that they have never thought at all about how people might react to the Moon being transformed into an industrial landscape – let alone the mythological, emotional and cultural impacts. From my experiences working with the environmental impact framework on Earth, I am pretty sure that people are going to have strong reactions, whether it is for or against. There is no human on Earth, living or dead, who has not interacted with the Moon in some way. Six hundred million people watched the Apollo Moon landing on television in 1969, and now we are seeing all of the lunar landing sites again through the eyes of the Lunar Reconnaissance Orbiter. We *ARE* all stakeholders in what happens to the Moon.

The first satellite in Space was launched only 60 years ago, with cherished replicas held in science museums. But today, with over 2,000 and a growing number of satellites in Space, featuring a myriad of designs, how can your field of Space archaeology keep up?

It is fascinating for the Space archaeologist as we are literally seeing the archaeological record created in real time before our eyes! I have to keep a sharp eye on the Space news to keep abreast of developments and trends in satellite technology, as well as innovations in Space junk removal. For me, it is also important to be part of the Space community, where I get informed and expert information about what is going on. (Sometimes the information flow goes the other way too!) There are also catalogues of orbital objects which are constantly updated; I rely on these to know what is up there and what is re-entered.

What is interesting is that Space junk, like other archaeological assemblages, is both knowable and unknowable. The tracked and catalogued objects are those generally above 10 cm in size, which is the limit of visibility from the Earth. The numbers below this size are an estimation based on returned spacecraft surfaces and laser sampling. There is a finite number of human objects in orbit, but we don't know what that number is. It is like the process of archaeological excavation, where you use two sets of sieves to extract the artefacts from the dirt you dig from the trench. The top sieve has a mesh with 5–7 mm squares; items smaller than that are caught in the lower sieve with a

> **It is fascinating for the Space archaeologist as we are literally seeing the archaeological record created in real time before our eyes!**

2–3 mm mesh. Smaller than that gets discarded on the spoil heap, and many artefacts manage to slip through both sieves anyway, depending on their angle. So we are always missing part of the picture. Space junk in Earth orbit is VERY like that!

You have looked at poetry and song lyrics about the Moon before and after the landings showing how scientific exploration killed the romance and mystery associated with it.

Actually, I am not sure that it did kill the romance and mystery – after all, look at the lunar hoax crowd! You could argue that the mystery has just been translated into a different arena. Throughout the 1960s and 1970s, our perceptions of the Solar System underwent a very interesting process as spacecraft flew by or landed on most of the planets. We gained data about their environments, geological history, how they looked close-up on the surface. The process of naming and mapping *geographical* features on the planets accelerated exponentially. The whole Solar System went from being mythical to scientific in under a generation. It is an incredible transformation when you think about it – and mostly people don't, because this is what is normal for us now.

But there was a real concern in the 1960s that something important would be lost when the mystery of the Moon was tarnished by astronauts tramping all over it. In the widely read Australian magazine *The Women's Weekly,* an unnamed author wrote, *Goodbye, romantic Moon. Poor lovers: it is black, hot and full of dust.* Well, it wasn't black or hot, but close-ups from various missions showed the grey surface pock-marked with craters, and this was becoming the dominant visual instead of the kindly glowing pearl in the sky, lighting the way for lovers to tryst. While we might have reconciled the lovers' Moon and the Moon of science, it is true that the Moon holds fewer surprises now and is being recast as a resource rather than a celestial body. These cultural perceptions are important, and I think we should be tracking this more.

I believe that scientific exploration of Space in itself is a romantic expression and yearning for closeness and connection. Maybe science didn't kill romance, it just moved the object of desire further away so it could maintain the *challenge*.

I am always suspicious of the narratives common in Space science and industry that there is an innate human

We can't imagine different futures if we don't understand the full range of human creativity and variability in the past.

urge to explore. If that is true, then you have to concede there is also an innate urge to conservatism! Perhaps it is more about being drawn to extremes, whether they are the deep ocean, the polar icecaps, or other planets and moons. As we come to know these places more, we have to go further and further out, or perhaps deeper in, to draw closer to the ineffable. I think we seek the ultimate meaning of life in these places. I think we are also looking for a galactic friend, someone else to talk to. Speaking of knowledge transitions, it was deep Space exploration in the 1960s and 1970s which also showed us that we were – probably – alone in the Solar System. Before that era there was always hope and I think we yearned for company. Until we got better data about the planets, we didn't know that we weren't going to find some other sentient species out there. I see this as another major shift in perceptions brought about by Space exploration that has been hardly investigated.

The current narrative about Space exploration oscillates between the utopian, the saving of the human race and peace reached by international collaboration, against the dystopian, where we will only bring all earthly disagreements, colonial impulses and diseases with us wherever we go. Are there any other options?

That is a good question and I don't know the answer. I do know that we have to make sure that there is a diverse range of narratives about how the future of Space might look. And this is where archaeology becomes really relevant: we can't imagine different futures if we don't understand the full range of human creativity and variability in the past. We may well have to look to Indigenous cultures to find new ways of adapting socially and technologically to unfamiliar frames of time and space.

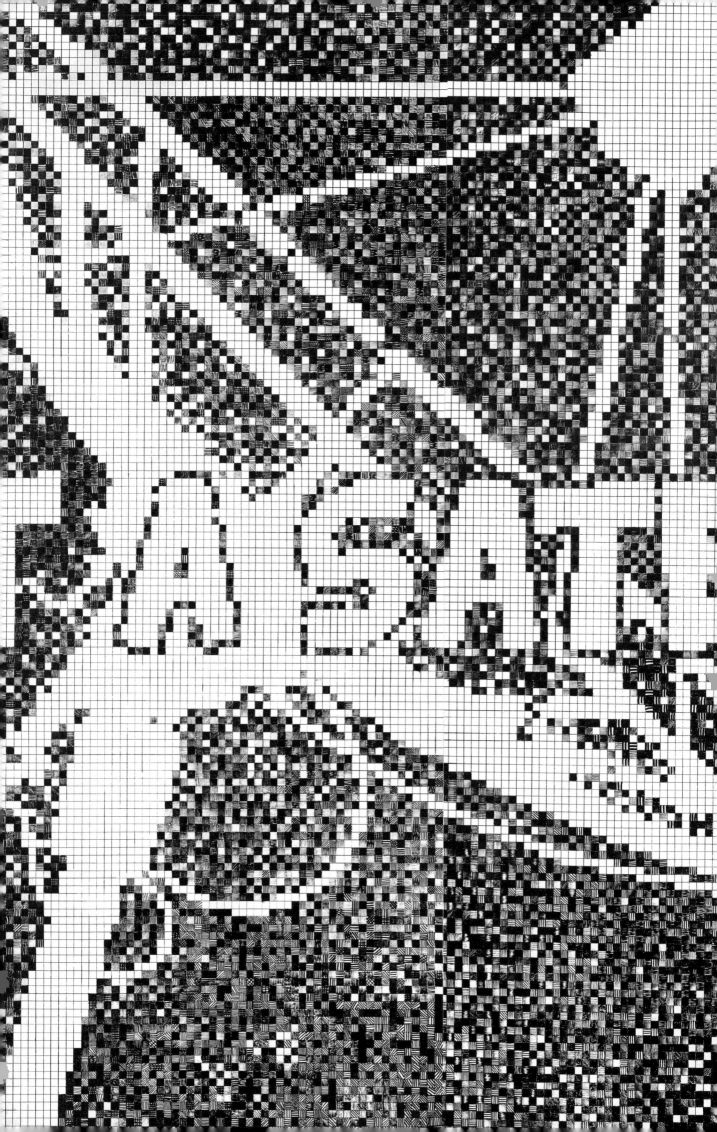

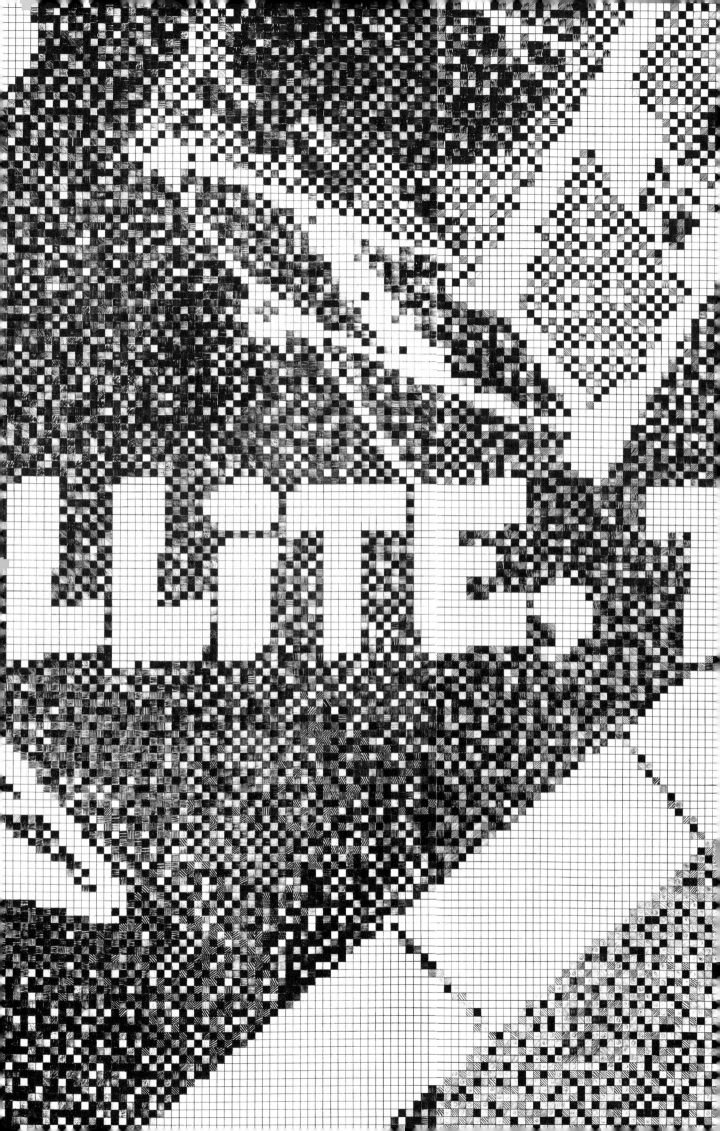

Aleksandra Mir
THIS IS NOT A SATELLITE,
THIS IS AN EDUCATED
NATION
fibre-tipped pen on
synthetic canvas
300×1400 cm, 2015–17

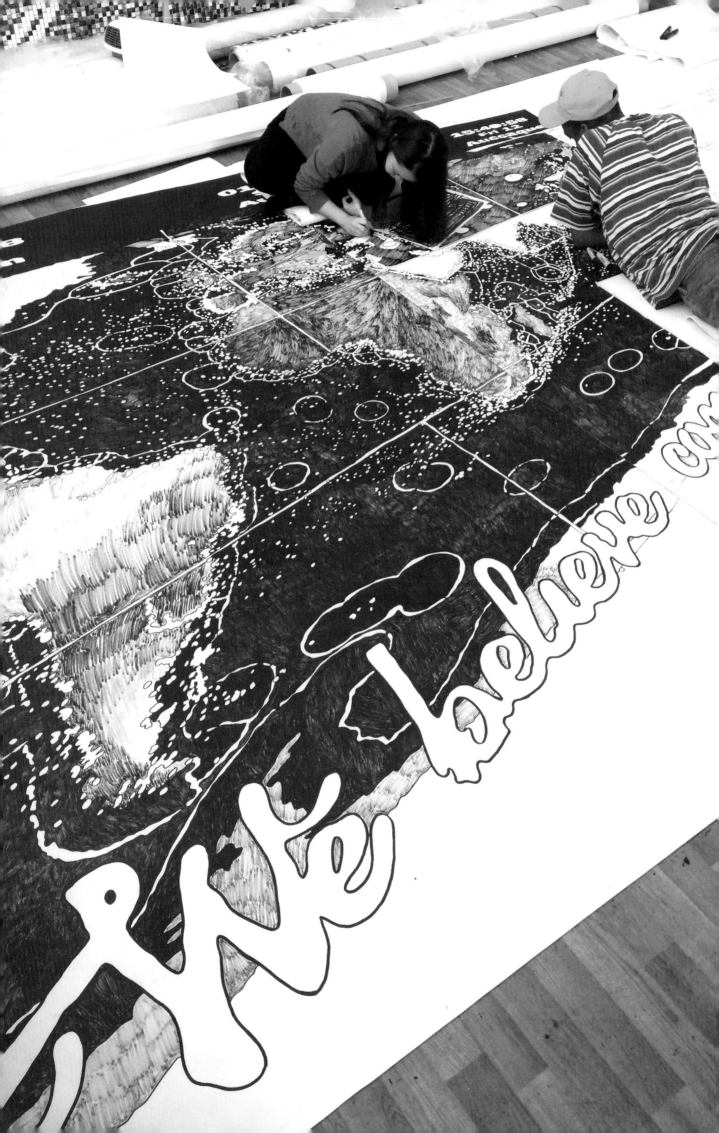

Every good story has tension

DELIA DI FILIPPANTONIO is a Design Thinker at the Satellite Applications Catapult in Harwell where she works on digital products and applications that make use of satellite data and technology.

ALEKSANDRA: You have the best job title, what does a Design Thinker do?

DELIA: I am not a designer in the very traditional sense in that I do not work with the aesthetic or function of objects. *Design Thinker* is a broad term associated with Service Design and Human-Centred Design. When designing an application, you need to consider the process end-to-end and determine at every stage how the user is going to experience the service. You have to keep the human, behavioural element at the core of the process. A big part of my job is understanding what the needs of the end-users are, for instance via ethnographic research or workshops. I also iterate and test ideas with them, so that the final result is essentially co-designed with the people that are going to make use of the service.

What role have the humanities played in your education?

A very big role. I studied Industrial Design at Central Saint Martins in London, but I did Classics and humanities studies back in Italy where I am from. There I had a great teacher who made us look at how literature and narratives are possibly the greatest evidence of how societies act and transform over time. Since then, I have always been passionate about storytelling and communication.

And now satellites are narrating those stories?

You can say that. Satellites, on a much broader scale, can tell us so many things about our societies. Satellite technologies such as Earth Observation, Communication and Navigation enable us to collect an unprecedented amount of information about mankind, data that offer insights into how people move, how cities develop, how crops grow, how the environment is reacting to human behaviour and so on. There are so many possible applications of these technologies – Space is just a great creative playground for designers and developers.

Assistants Arielle Tse and
Jerome Ince-Mitchell
Aleksandra Mir Studio

Navigation studies were the original purpose of the Greenwich Observatory, which has a nautical-themed architecture. Here at the Catapult Operations Centre you are standing in front of a large nautical-themed digital world map. What are we looking at?

This map shows the traffic of vessels on the world's oceans, captured live in June 2015, and the data is played back for demonstration purposes. This visualisation is a demo of a real-life project that helps authorities worldwide to monitor and tackle illegal fishing activities. It displays different colour-coded types of vessels, for example fishing or cargo vessels, and for each of those it can show information such as name, origin, direction and speed at which they are moving. It uses a mix of satellite data and other datasets to help spot trends. With this tool, a team of analysts has a great amount of information to understand whether a vessel has possibly been involved in illegal activities.

It is very dramatic. Good guys and bad guys. Are you interested in the drama as well?

Every good story has that tension between positives and negatives. If we look at this visualisation from a purely narrative, non-contextual perspective, you could tell that on this screen we are constantly watching the story unfold on the global stage.

So who directs the drama in this case? Who brings their scripts and how do you decide what to take on?

We use the UN Global Goals to inform part of our strategic direction and to frame our vision and mission. More and more organisations worldwide are talking about the Goals, and, being in the industry with probably the most global view on how the world moves on, we really feel that there is something we can do to address each of these areas.

Tell us about the future.

The future is looking great! Space technology and data are getting more and more democratised in cost and accessibility and that is already opening up great possibilities for everyone that wants to get involved. And this is not just about upstream opportunities like Space tourism or launches, but also applications and services to be developed here on Earth. For instance, there are already some examples of videos taken directly from Space and we will soon be able to see things move and change in near real time and at great resolution. I am also personally interested in seeing how other technologies will integrate with satellite data. For instance, we can already re-create and explore environments at a high degree of realism – places that could be miles and miles away from you – using 3D modelling technology mapped with satellite imagery.

We are constantly watching the story unfold on the global stage.

The technology itself can serve many different purposes. Have you worked on any evil project?

Luckily I have always been involved in projects that worked towards positive impact or that enabled others to do so. But maybe I haven't found the evil mission control room just yet!

Aleksandra Mir
WE BELIEVE COMMUNICATION IS A BASIC HUMAN NEED
fibre-tipped pen on synthetic canvas
300x1000 cm, 2015–17

The future is looking great! Space technology and data are getting more and more democratised in cost and accessibility and that is already opening up great possibilities for everyone that wants to get involved.

Third Generation Communication

ANDREA MORETTI is Manager of the Network Control Centre at Inmarsat, London. His role is to make sure everything works perfectly.

ANDREA: This is the Network Control Centre where you can see the global coordination of all our activities. Here are four satellites of the fourth generation. Over there are three satellites of the fifth generation. We don't have a graphic representation of the third generation but you can see their flight data. This is all to impress you!

ALEKSANDRA: I am very impressed. What is the minimum number of satellites you need to view the whole globe?

Imagine the Earth, draw a circle at the equator and go up 36,000 km, what is termed a geostationary orbit. If you put three satellites separated by 120 degrees on this orbit, you basically have global coverage. Then we use a fourth to provide additional capacity for an area where there is a lot of traffic, such as areas where commercial vessels or passenger aircraft are converging.

Are there any blind spots?

The only limits are the North and South Poles.

How long has it taken to develop a system that requires only three eyeballs from which to observe the whole Earth?

When we started the mission in 1979, we rented the capacity from other operators. We didn't have our own satellite at first. The first satellites owned by us were the second generation, the last of which was decommissioned a few years ago. At the moment we are already preparing the sixth generation, the first of which will be launched around 2020.

You already have maximum coverage. How much more could this evolve?

We continuously need to offer additional services and additional capacity to our customers. This colour here gives us an idea of how much of the capacity the system is using. By looking at this wall, you have an immediate picture of what our system is doing in real time.

It is quite beautiful.

This is very nice to look at, but it is not our only tool. If we detect a variation on any part of the network, this will cause an alarm. So for example, if a number of users leave the network at once, it could be absolutely normal, but it could also be symptomatic of a problem on the network, so then the alarm is raised.

Are you only busy when an alarm comes on?

The saying is that a good day is when nothing happens, but in fact we are always busy with what we call the *daily operation*. There are two tasks to the daily operation, one is the monitoring of the system and if something happens, we take action. The other is taking preventive actions. We do backups and continuously check that the system is working fine. With experience, we are able to spot possible causes of problems in advance.

Seafarers have always looked to the sky for orientation, so what is the current function of satellites on the sea?

Inmarsat was created as an NGO in 1979 for providing a maritime safety and distress system with global coverage. We were the first and are still the only company who offers that. And over the past 20 years or so, we have been providing the same safety system to our aeronautical partners. So, lifesaving is our first mandate and still very important, maybe not from a commercial point of view, there are other areas that make much more money. Whenever there is distress, it is clearly visible on this wall. One of the beams becomes red.

You can see a distress signal from one single vessel?

Yes. I can check the name of that vessel and make sure that the call has been forwarded directly to MRCC, the Maritime Rescue Coordination Centre, which then sends the signal on to their local branch.

So you are telling me that right now, everyone is okay on sea? It is hard to believe. I would think that given how accident prone we are, the wall would be blinking like a Christmas tree the whole time.

With the Global Maritime Distress system, there is legislation for all craft of a certain size to have our equipment on board, just as it is mandatory for certain vessels to have life vests or signalling rockets; but smaller leisure craft aren't required to use our equipment.

It was one of your satellites that picked up the last identifying signals of the disappeared Malaysia Airline flight. The communication between the plane and the airline had been shut off, possibly by the pilots or anybody else on that plane, but you were still able to detect it. How did this happen?

It was an unusual situation for us because it was not picked up by a safety system. We didn't receive any distress call. In that case, it was actually the use of our experience and our engineers who worked with mathematical models to calculate the route the plane could have taken.

Retroactively?

Yes, it only happened afterwards, when we were contacted by the company that sold our service to the airline and asked us to assist with the search. If that plane had been using our safety system, it would have been located immediately.

You are located on one of London's busiest roundabouts, Old Street. How safe are you and all the technology here?

If anything happens to this building, we have a backup centre exactly like this in another country.

You could go to work there tomorrow and it would be exactly the same?

Yes, we in fact do it twice a year.

Everyone needs a backup workplace. I am a local artist. My studio is only ten minutes from here and you are very welcome to visit my Operations Centre. It is not as technologically advanced but still manages to communicate with the whole wide world. I also work with a team of people and we are making a big drawing of a satellite operations centre so I wanted to come and see yours. This environment is so inspiring and yet very few people are aware it exists or how their lives are affected daily by satellite technology.

But they don't have to know how it works to use it. If you were following the first Gulf War, 1991, it was the first time that CNN went there with journalists following the troops; they were sending information in the same way every war correspondent from the First World War onwards has done. They would take and send their pictures, which eventually made it into the papers or the movie theatres days or weeks later. Today, journalists who are following the action in Mosul have equipment to send a live feed via satellite to your personal device in real time. So now you know what is going on in Mosul, as it is happening.

With satellites, there is this realm that remains entirely invisible unless I invest myself in knowing about them – not necessarily knowing how they work, but just knowing that *they are even there*.

But that is true for most technology people use every single day, they don't realise it is even there. The GPS system in your car is run by satellite but you don't have to worry about what is above your head.

If anything happens to this building, we have a backup centre exactly like this in another country.

I like the idea of knowing what is above my head. And for you, when you come out of this extraordinary environment and step out in traffic, do you bring you awareness about advanced satellite technology along, or do you switch off?

It is always there. Commercial satellites go back to the end of the '60s. I have been working with satellites for 24 years and my father also worked in the business for 43 years. He did telemetry services for satellites at Telespazio in Italy from 1967.

Yours is a first generation satellite family, and you are the second generation.

And my grandfather was working for the navy, in the Marconi Room. So actually, I am *Third Generation Communication!*

Aleksandra Mir
WE BELIEVE COMMUNICATION IS
A BASIC HUMAN NEED
fibre-tipped pen on synthetic canvas
300x1000 cm, 2015–17

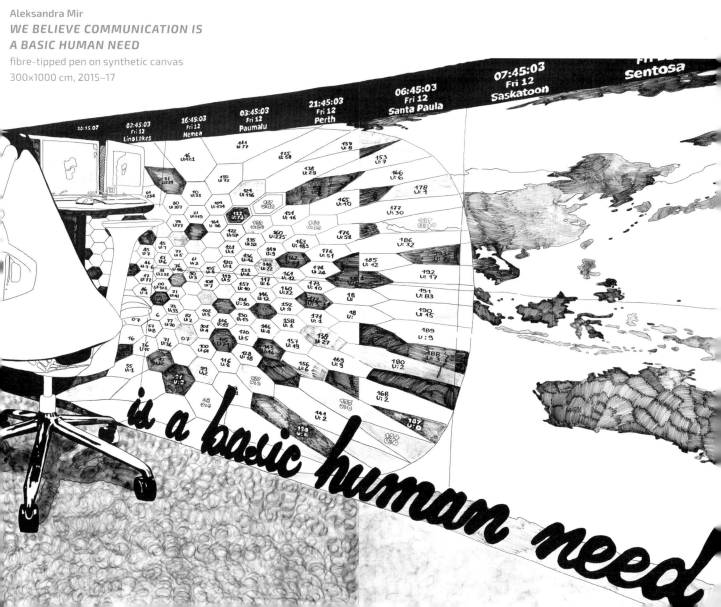

Ghost buster traipsing the bog

ALEKSANDRA: You caught my interest when I heard you speak at a conference in Llandudno, Wales about using satellite technology to avoid getting your feet wet in a bog.

REBECCA: I used satellite data to map the biodiversity of one of Britain's largest and most intact lowland raised bogs called Cors Fochno, situated near Aberystwyth in West Wales. Much of the bog was difficult to traverse and a number of students who helped me out with field work were a little surprised to be bumping into the odd snake basking in the Sun. Even traversing some of the areas near the boardwalk I or fellow field workers ended up sinking up to our waist or a leg stuck for what seemed like an eternity whilst we finally managed to release a foot from a wellie which had disappeared in the depths, and woe betide us if there was lightning whilst out there! The reserve manager informed us that lightning was probably the most dangerous aspect of working on a flat bog, where you are the tallest object for miles.

You had to get out of there to stop risking your life.

I wasn't really risking my life as one has a choice not to go into life-threatening areas, but this then means that there is a lack of data to support the research. This is where satellite data is extremely useful for filling that field data gap, in order to get a better understanding of the whole landscape.

To avoid disappearing into the depths I mainly used the accessible area of boardwalk for field work across the bog. I also used a field *spectroradiometer*, making me look somewhat like a ghost buster traipsing across the bog. This provided data similar to that which comes from certain satellite instruments, and was used for comparison with the satellite data, but without the atmospheric interference that occurs between satellite and Earth. Using this gave us a better understanding of what times of the year satellite data would provide the best discrimination between species for analysis.

What species are you looking at?

REBECCA CHARNOCK is an Ecologist who studies the Cors Fochno bog in Wales using satellite data. She is also a Business Development Officer in the Department of Research, Business and Innovation at Aberystwyth University.

Aleksandra Mir
SLOGANS
fibre-tipped pen on paper
50x70 cm each, 2015–17

Typical bog plant species such as *Sphagnum* and *Eriophorum* are found in the wetter and more intact areas, whilst *Molinia* is usually an indicator of degraded bog. Non-ecologists soon got the hang of which plants indicated the wetter regions by discovering which were safer to stand on. *Don't step on the Sphagnum!* was a typical first cry as they disappeared up to the top of their thighs. Students soon learnt which plants were *Sphagnum* by the depth they disappeared to, and it was a good lesson in showing that varying coverage of specific bog species can indicate the condition of the bog.

How have satellites improved the conditions for your research?

In the past, one of the ways in which conservation managers have measured the condition of the bog was through the percentage coverage of *Sphagnum* in the central dome region, a measurement taken by eye from the ground and taken from the area that appears more raised (as in a dome). Using Earth observation data to identify the dome and then classifying and calculating the regional *Sphagnum* coverage provided this information in a way that is spatially more accurate and does not have the affliction of individual opinion; something that has never been done before.

How did ecology discover satellites?

There has always been the need to express field data results spatially and this is done by drawing on OS maps, using aerial imagery and more increasingly now using satellite data. Instruments that record and monitor have shifted from aeroplanes to satellites and this along with new and continuing concern about changes in our environment – whether caused by human activities or climate change – has fuelled the continuous development of satellite data for this purpose.

What scales are you working on?

We get satellite coverage on many scales, from the local protected site level to a global scale, and it can also provide derived information that cannot necessarily be seen by the naked eye – for example, nitrogen content, biomass etc. Different scales of information required can dictate which methods of monitoring are used but with satellite data resolution increasing temporal frequencies like never before, and the data now being more freely available, satellite data is being increasingly used. Of major importance to many walks of life is the fact that satellite data now allows us to monitor change whatever the cause.

> ## Students soon learnt which plants were Sphagnum according to the depth they disappeared to.

What other satellite data projects would you promote?

For example, scientists at Aberystwyth University (with support from the Japanese Space Agency and NASA) who map changes in the extent of mangrove forests across the whole world. They have been able to quantify the devastating loss of mangrove habitats across the tropics and highlight how some of the main drivers behind this change, such as climate change, drive sea level change and the conversion of mangrove forest to shrimp and fish farms. The loss of mangrove forests also has a significant impact on global carbon storage, as well as reducing natural defences against tsunamis.

There are many other useful areas where satellites have been used but those that explore global health issues are of particular significance. For instance, researchers at Aberystwyth University have been investigating the use of satellite data to map mosquito aquatic habitats in places like Tanzania, Zanzibar and Zambia. By mapping these water bodies from Space we can help to target public health interventions for eliminating diseases like malaria, dengue fever and zika virus.

From these examples one can see the potentials for this technology are boundless. It is through the continued interactions and collaborations between academia, business, support organisations, and government that we can make some large steps forward in our knowledge and use of satellite data.

Engaging with the future

A reflection on your success

Do you want to be part of the space future?

Universal Space Interface Standard

In space, we've got you covered

A history of stellar achievments

We enable worldwide communications

Beyond Limits

Bringing Life to technolog

Quality. Flexibility.

Quality.

Flexibility.

We deliver cutting edge scientific missions

Jobs in Space

Local expertise, Global presence, A Universes of applications

In space, we've got you covered

We make possible global positioning and timing

Do you want to be part of the space future?

A reflection on your SUCCESS

We're ready to take the next giant leap

Jobs in Space

30 years of space and innovation

Bringing life to technology

The space you need to get your business off the ground

Engaging with the future

Beyond Limits

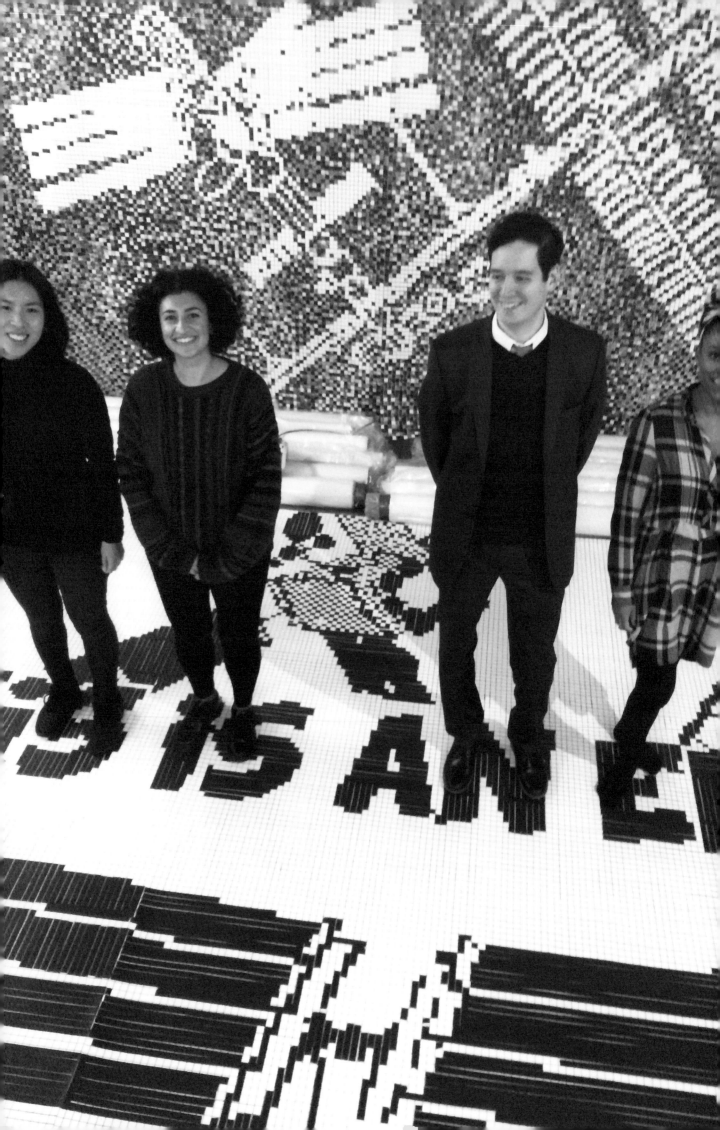

The bigger picture

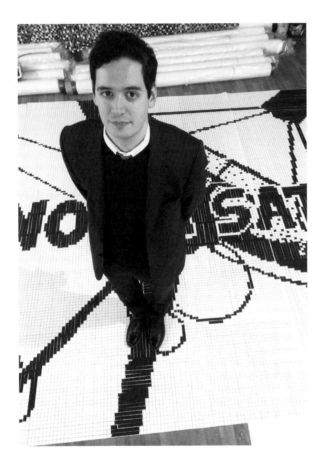

ANDREW KUH is an intrepid Space bureaucrat. He is Technical Regulation Manager for the UK Space Agency's Satellite Launch Programme, and previously managed the UK's Human Spaceflight and Microgravity programme.

ALEKSANDRA: You call yourself a Space bureaucrat but I know you as a great humanist. How does one do what you do?

ANDREW: Well, it is a bit embarrassing when I speak to people who want to work for us and ask the same question – *how do I get to do what you do?* I never dreamt of working in Space. I studied Philosophy and Cultural studies. My undergraduate dissertation was on Kandinsky! I worked in the art bookshop of Arnolfini in Bristol for two years. It was a dream job but I was made redundant. Then I was a white van man for six months, then worked for a drug rehabilitation charity, then the Art and Humanities Research Council and a small step from there to the Science and Technology Facilities Council and when the UK Space Agency was formed, my role was merged into it.

Those are incredible leaps.

I experience the difference to be greater between the positions I have held within the Agency than the switch from the humanities to science. Managing their grants is very similar. They can sometimes be upset when you tell them this, but philosophers and physicists are fundamentally quite similar in many ways. When you work in a discipline that has been going for a thousand years you really need to contribute something extraordinary, or find a very particular niche. The main difference, although grossly simplified, is that the physicists tend to believe there is an objective truth which their research is uncovering, and the philosophers don't necessarily.

And the work you do now?

We are the government coordinating body for all sorts of Space activities – science, launches, communications, navigation, industrial strategy. But in my current role I design policy, which gets converted to legal speak and then comes back to me and hopefully it is what I first had in mind. So right now, I am mostly arguing with lawyers about nomenclature.

Andrew Kuh with assistants Moira Lam, Yasmin Falahat and Joanna Vanderpuije
Aleksandra Mir Studio

You are deciding on what should be allowed and what shouldn't?

We are clearing the way to make things possible. Right now, we are preparing for rocket launches and suborbital flights from the UK, which has never happened before so the concern for me is mostly about safety. Ideally, depending on what you're launching and the type of operations, the location should be remote and the industry has to pass certain safety regulations.

Will we be able to watch?

These are likely to be remote locations, depending on the type of operation...

I don't mind remote. Can I go there to watch?

That's why I have to make sure you are safe without dampening your enthusiasm or support. The primary principle of any regulations will be ensuring the safety of the general public. That said, there is by necessity some risk in everything – we just have to make sure it is reduced – as *far as is reasonably practicable* – that's the jargon. So, if you can watch, and if so, how closely, will follow safety considerations.

Thank you. How do you assess the risks?

I just went up to the Peak District where we commissioned the Health & Safety Laboratory to do a study for us on this topic. These people have the best jobs, they are basically just blowing things up all day in the most beautiful place. They recreate industrial accidents, make statistical calculations, all sorts.

What is the breaking point for a decision like that?

It is a very careful decision. We have to determine the acceptable level of risk and we have a duty to make sure that all the relevant evidence from tests is used to make really robust assessments of risk, and that this information is then assessed in a consistent manner. Figuring out the best way of doing this is preoccupying me at the moment!

But when you are launching brand new types of vehicles, how do you go about assessing their reliability?

Well, that's all part of the challenge. You can refer to similar systems; you can use the manufacturer's test data. But the newer the technology, the greater the risk, and so the more cautious we will be. Especially in a complex system like a rocket launch, where the risks will compound one another; uncertainty can be multiplied by uncertainty – and inevitably there may be scenarios where the risk is too great and either more testing is needed or some different system will be needed.

Worries on top of worries.

> *I was the youngest in my team when they were debating a mission to the icy moons of Jupiter, which was expected to arrive in 2033. The chair said, Well Andrew, I hope you'll enjoy this because the rest of us will be dead by then.*

Yes. But that's why we're working hard now to understand the potential risks and design a way of assessing them. Also, if I were to be a bit glib, I could point out that the fundamental technology – i.e. rocket engines – is decades old, so it's not *that* unknown...

When do you expect to see the fruits of your labour?

We are looking at the early 2020s. So, it might be my 40th birthday present to see a successful rocket launch.

Excuse me for saying this, it is really meant as a compliment, but you are *incredibly* young for the job that you do. Does the agency hire young people on purpose?

No – in fact the civil service is commendably even-handed in recruitment – but as an Agency I feel we are quite young. I mean the Agency itself is only five years old. When I started I was the youngest in my team and we had a committee meeting where they were debating a mission to the icy moons of Jupiter, which was expected to arrive in 2033. The chair of the meeting said, *Well Andrew, I hope you'll enjoy this because the rest of us will be dead by then.*

People working on Space must have a really healthy approach to their mortality.

I don't know about that. It is just being pragmatic. These things take time. They have always taken time so everyone is prepared to wait. And when you are involved with things that have never been done before, or exploration, you always announce a completion time, but you also know that things will get more complicated as they develop.

People working on Space must have a really healthy approach to their egos.

What *does* impress me, and runs counter to individualist, scientist-hero, egotistical stereotypes, is that people leading these missions must sublimate their own egos.

> # *Space exploration is a cultural pursuit, about more than merely science, and as such we in the sector might learn something from what artists have to say on Space exploration.*

They know that they might not get the recognition and glory of their work while they're still alive.

You have written about art on the UK Space agency blog. How do your interests intersect?

I am not particularly interested in science fiction, which is maybe the most obvious intersection. What really interests me, like with the similarity between philosophers and scientists, is this idea that artists and scientists are pursuing the same or similar goals, but through different means; that scientists are just as creative as artists, they just follow a more definitively codified practice. And that Space exploration is a cultural pursuit, about more than *merely* science, and as such we in *the sector* might learn something from what artists have to say on Space exploration.

You see a lot of people across many disciplines. You must have a really broad view from where you are standing. If I asked you, *What is going on?* What would your response be?

Bloody Hell.

What is the bigger picture?

This project you are working on is probably the most important thing we are involved with right now.

That is very sweet. You have been my no 1 supporter on this project from the start.

Ha, do I get a special badge? But seriously: we *do* need a greater engagement with art – and I think there is a tendency towards this at the moment. We are realising that chasing the notion of scientific objectivity isn't sufficient – dynamic scientists know that. Science is a social practice; projects like yours are critical to bridging the perceived divide between types of knowledge.

Sometimes I think you have more faith in my project than I have myself. What you see here on my studio walls is just one of many possibilities; this is a bubble where we can cut the world out and just draw dots for a month. The difficult and most important work is in the connections we are able to make with the

world outside the studio, and how what we do here connects with other practices. There is too much going on in-between to ignore the relationships or the social sphere that we share. What will we collectively achieve in 2017? What are the questions to pose for the future?

Right now we are starting to prepare for Space tourism, there are all these people who have already bought their ticket ready to go. For insurance purposes, one needs to decide what to call them. Because of the risks involved, it would be suitable to call them astronauts, but that would offend professional astronauts who go through a rigorous training and selection process.

Astronauts are heroes.

At the same time, the ticket holders don't want to be called mere tourists.

Tourists are trash. Space deserves better.

Not sure about that! But for now we have settled on calling them *Spaceflight Participants*.

That sounds very like 2017.

We are shaped by gravity

THAIS RUSSOMANO is a medical doctor who specialises in Space Physiology, Aviation Medicine and Tele-health. Thais is the founder of the MicroG Centre at the Pontifical Catholic University of Rio Grande do Sul, Porto Alegre, Brazil.

ALEKSANDRA: You are the founder of the first and only *Microgravity* research centre in the southern hemisphere. I thought Space was all about *Zero* gravity.

THAIS: Zero gravity is where there is no gravitational force whatsoever. The planets in our Solar System are too close but farther away into deep Space, where there are no stars or planets, only there do you find absolute Zero gravity. For us Space medics who study the effect of this force on humans, such as, for example, the astronauts at the International Space Station, it is not correct to say that we are studying them in Zero gravity because they are still subject to gravity. The acceleration of the spacecraft as it orbits the Earth is enough to counterbalance this gravitational force, so the astronauts are effectively in a perpetual free fall, which we call Microgravity.

As a medical doctor your subject is the human body but as a founder of this institute you have also made room for other activities.

When I established the MicroG Centre 17 years ago, at that time it was only a lab and I didn't want to simply name it, *Lab for Space Medicine* or *Space Physiology*. I wanted it to carry this greater idea of Microgravity as a concept related to Space. It is now a centre of research and academic activities dedicated to three areas: Space Life Sciences, Aviation Research and Tele-health. Space Life Sciences is a broad field, including Space Physiology, Space Pharmacy, Space Biomechanics and Space Biomedical Engineering. The area of Aviation Research is also subdivided into Aviation Science, Aeronautical Science and Aviation Management. And there is Tele-health, which combines computer technology, IT and many different health areas such as Cardiology, Dermatology, Pharmacy, Odontology.

Tele-health is your baby.

It is a very, very interdisciplinary lab inside an already very interdisciplinary centre. The other two labs integrated with it are the Imaging lab, which is basically for medical images, and the Usalab, which is

the most recent one. It is a lab where we can create simulations to improve the usability of medical devices and medical scenarios. We can create, let's say, a practice environment like a surgery theatre and work with companies that develop the medical treatments to give them feedback. The Aviation lab could have a scenario that is an airplane cabin, where we can practice delivering medical care for a passenger. The idea is always to be working together. In any meeting we can have around five or six people and they all come from different areas.

You have talked about creating an arena for cultural output as well.

Oh yes. All these labs will somehow be developing either products or projects or activities to create some revenue. The MicroG Labs Network is the international development of Microgravity activities in different countries. The MicroG Entrepreneur is the bridge to the industry, royalties and patents. The MicroG Culture is the bridge to the arts, exhibitions and society.

These are public stages for the lab research?

The bridges between society and academia. I would say it is the future. Of course we will always have lectures and papers, all that, but eventually it has to reach out somewhere.

You are taking an active role in how the fruits of your academic labour will enter society. Why is it important that this expertise has an impact on culture?

Science is always part of culture. The pyramids in Egypt are part of our civilisation, our culture with our science behind it. There is science in everything.

And now Space paves the way.

Space makes the world a globalised place. Space pushes the limits of imagination. Space is very disruptive, *What is out there? Do we have friends out there? Can we communicate with them?* The next step is to leave Earth and to culturally integrate this idea into society, the way science fiction and the TV series do.

I think that the actual problems are more interesting than the endless possibilities. I am not bothered with sci-fi and fantasy, which is too easily available, like being on drugs all the time. It is not what I am interested in. But I get the feeling that artists like me are just annoying because we question everything, like a constant rash or irritation. How does medical Space science push progress on Earth and what are its limitations right now?

Many of the technologies developed for Space science or Space medicine are also applied to terrestrial medicine. A good example is the rover that the astronauts used

> ### The idea is always to be working together. In any meeting we can have around five or six people and they all come from different areas.

on the Moon – they had to coordinate the movement of the rover with their chin because they needed their hands available to collect rocks and to optimise the time. This was then referred back to Earth and using the same technology, paralysed patients could control their wheelchairs with their chins.

Another very important thing is that when you go into Space you create a completely different type of lab in an entirely different environment. As scientists we have these two big laws. If something in science is true, you can reproduce it wherever you are. Give me the same conditions and I will be able to reproduce it. That is one big rule. The second rule is that if you think something is true then you can also extrapolate it. If you change one of the variables you will be able to more or less guess what's going to happen. Taking humans into Space we go for the second rule. If I take gravity out I can more or less predict what will happen. But some of the findings in medicine prove the opposite.

Doodle by Aleksandra Mir created during the ELIPS: Life & Physical Sciences in Space conference Imperial War Museum, London, 2015

> **Those media exercises are a mixture of really wanting it to happen, while also having to wait for the real breakthrough.**

The rules of earthly science don't necessarily work in Space.

There are two things going on here. Either we can't know what is going on because maybe the presence of gravity is so strong it prevents us from seeing everything clearly, or, gravity has other effects that we don't know about yet. So instead of having the symptoms of science that were predicted here on Earth, we go into Microgravity, and get different results. It questions the medical technology. This is a huge contribution to science because it is really very disruptive.

You have to start from scratch up there. Do you think all those ambitious initiatives to reach Mars are premature?

Going to Mars is not a big issue. We have had robots and unmanned spacecraft going there for decades. But the promise to take humans to Mars?

It is not just Hollywood making it up. A TV company is casting participants willing to go one way and they make it sound like they are ready to go tomorrow. Other entrepreneurs are very confident in developing their vehicles.

I think that when it comes to the human body, we are still very limited.

I often hear it said that, *We have to imagine it before we can do it!* But this reality-TV show sounds irresponsible, confusing and trashy. Do you think these seductive media exercises serve a necessary visionary function or are they just distracting?

It might be giving false hopes that shouldn't be taken too literally. But I don't think it is necessarily wrong. Many times people question why it is taking us scientists so long, *Why are we not there yet?*, *Why not just send someone?* It is not simply that we don't want people to die on their way. It is that we don't really understand the risks or how much is known in terms of physiology and medicine for astronauts in Space. So those media exercises are a mixture of really wanting it to happen, while also having to wait for the real breakthrough.

If we are willing it on, cheerleading, *Go, Go, Go*, maybe we will get there faster.

The Moon landing program was groundbreaking for mankind, but in 1972 the Apollo program died off and ended. Maybe we should have kept going. It is only a three-day journey away and there are risks, but the Moon is still much closer than Mars.

The Moon is old hat and we are always yearning for novelty. The reality-TV company which is recruiting travellers to Mars is exploiting that.

We have barely scratched the surface of the Moon. Maybe we should first have exhausted its possibilities.

> ## *We can insert gravity into your spacecrafts, Space stations, Space habitats, the Moon, or on Mars, to transform these spaces to mimic Earth, to survive in these alien environments without actually changing ourselves.*

Imagine how much research on humans, cells, plants and animals we could have done in 50 years? There is a huge lack in knowledge, and now we want to do something even more complicated, face radiation and the environment of Mars and then come back alive and well. If in 50 years we had spent more time on the Moon, then maybe by now we would have had a better understanding of what it is like to live outside Earth. Space Psychology and Space Psychiatry would have evolved a lot, but we lost 50 odd years and we still don't know how people will experience this environment long term.

There's little conversation about psychology among the visionaries. We can easily sacrifice going mad in return for just getting there.

It is all about Mars, Mars, Mars, which is good but are we really prepared for it? Building the International Space Station has been a huge international project. It was a big step, not just scientifically but also in terms of international politics towards a more *collaborative* exploration of Space. It could have been the same with the Moon. Being there now would offer a completely different scenario for what happens next and how.

When they were constructing *Skylab*, the first human settlement in Space launched in 1973, they were looking at different design ideas and one of them was to build a big rotating wheel that creates artificial gravity. This idea was fully articulated in the movie *2001* as an environment where one can jog and lead a seemingly stylish and leisurely lifestyle. But when they actually tested a model of it on real astronauts, they didn't like it but preferred dealing with the deteriorating effects of Microgravity because they were getting motion sickness from this fantastical wheel. So what is it going to be?

It is a very difficult situation. After six months to a year in Space, you become submitted to long-term exposure of Microgravity. Some of the effects can be counter-balanced with exercise or diet, but there are also changes that might be very damaging to the astronauts. Very recently it was found that the pressure inside the brain increases. We might come to a point where humans won't be able to stand Microgravity beyond a certain number of months. So if we do go to Mars eventually, the solution with the spinning wheel may be revisited. It creates *Hypergravity*, a centripetal force, which does not really exist as a force.

We barely understand these effect on humans?

We have only explored humans in Space since Yuri Gagarin first went up in 1961, so we have merely had half a century of experiments. Space Life Sciences compared to other Space sciences also develop very slowly because it is very costly to send and keep astronauts up there.

Is that what your research centre is trying to make up for?

Yes, but we do not have the radiation and the psychology is different. Even if we try to understand it through what's called *Space Analogues* it doesn't give us the full picture. It is very complicated and I think that if nature took millions of years to shape us to the point where we are now, it would be useful for us to first understand how we can adapt to Microgravity over 50 or 100 years, or even over 1,000 years – and maybe this is not even enough. We are shaped by gravity.

So if we decide to leave it, we still need to bring it with us, what a dilemma.

We have three possibilities. We can reconstruct the atmosphere inside a spacecraft to have 20% oxygen, a controlled temperature, CO_2 and nitrogen. We can mimic that somehow but without the gravity and with radiation in a landscape that is much more severe than anything on Earth. So then we can decide to also add gravity to the scenario and ideally also some good protection against radiation. We can insert gravity into your spacecrafts, Space stations, Space habitats, the Moon, or on Mars, to transform these spaces to mimic Earth, to survive in these alien environments without actually changing ourselves. Or, we can take years and years to try and come up with enough knowledge and technology to overcome the effects of Microgravity, or we can simply give up and not go into Space.

If you would give Space exploration a million years, do you think that we could enter another phase of evolution where eventually we will get rid of all the things that we don't need, like legs, to become a truly Space-faring species?

Maybe that would be a fourth option, if we some day start reproducing in Space, if the pregnancy happens in Space and these beings are born and evolve in a Microgravity environment, then they may be better adapted to it and will potentially develop into different babies than on Earth, and subsequently into different adults. Nobody knows. It is pure fantasy now but I think that the options are there.

> ## *I was very lucky to have been born with this Space dream. From the age of four, for as long as I can remember, I wanted to be part of Space Science.*

If they are even defined as humans at that stage, or another species. We might regress back to being fish, very intelligent fish, inside self-inflicted fishbowls. That is what the International Space Station already appears to be like, a fishbowl with smart fish struggling against the impact on their useless legs.

Or you give up and stay here.

Stay here. Enjoy your predicaments, and legs.

I don't see other options, maybe someone has other options, I don't know.

Your fascination with Space started when you were a little girl. You would play astronaut in your room and when your mother called you to dinner you would yell, *Mother close the door, I need to return to Earth first!*

I am on another Galaxy!

When you were in medical school you would read textbooks but on the side you would devour sci-fi. Did you have to shed your childhood fantasies about Space or are they still part of what you do?

If something is part of your childhood it is always going to be part of you. But one thing is to be a child and use chairs as spacecrafts in a magical world. Another thing is to wake up early, go to meetings, test subjects, write papers and give lectures. This is more realistic of course. You can say, *Oh this dream became a reality.* But a dream never becomes a reality. A dream is a dream. A dream is full of emotions that never become reality but the *intention* of the dream, the main idea of what the dream is about, yes, I think it can become a reality. It is like a science fiction movie. You are there, seated watching this fantasy but as soon as you step out of the theatre you are in the real world. I feel that these are two different things but I believe that I was very lucky for some odd reason to have been born with this Space dream.

From the age of four, for as long as I can remember, I wanted to be part of Space Science. I didn't know exactly what it was but I was dragged in by this idea. Sometimes students come to me and say, *I am not sure what I am going to do.* I never experienced this feeling. I was always sure. How can you not know at 20 years old? I knew when I was four! So some people are just born with this desire. It shaped my life, that's for sure.

How does this desire feature now when you are on the global stage of Science?

I always have this emotional and personal attachment to what I do so when I am out there talking about my life's work, I am more exposed than if it was just a job for money. If the work you do is related to your dream, you become a bit more vulnerable.

There was a moment when you applied to become a real astronaut but it failed. How did it play itself out, your ambition, your vulnerability?

Brazil selected its first astronaut in 1998 and I was very well prepared. I had completed my masters in Space Medicine in the States, my PhD in London in Space Physiology and I had lots of relevant training. I was really very prepared for such a position but the government at the time decided to choose a person from the military – no civilians such as me could apply for the job, even if they were qualified. The selection happened behind closed doors and that was that.

Again, because it was related to a childhood dream and I had worked so hard for it, the first thing I felt was a sense of betrayal, of injustice. I felt it was not fair to exclude civilians. At that point I knew I was never going to be an astronaut because I thought by the time another opportunity came along and if civilians were allowed to apply, my time would already have passed.

It was a tiny window of opportunity.

I remember that there was a movie out, *Contact* with Jodie Foster that was more or less the same story. She was a child that wanted to contact aliens so she worked hard to qualify herself in that area. Then there was this chance for a trip to another planet to contact aliens but she couldn't go because a military person was chosen. When all this took place in Brazil, a reporter phoned me and we spent about two hours on the phone chatting about it, because in his mind, I was experiencing the same situation as Jodie Foster!

How ironic.

It was terrible in a way because I had lots of media support to become an astronaut in Brazil, lots of TV, radio, and newspaper coverage, they were wonderful and were all backing me. I still have copies of some of it. Anyway, as soon as the first astronaut was publically announced, they came back to me looking for explanations. But the decision had been political so I couldn't say much – I didn't want to get involved in the politics of it all. But all the questions coming my way meant I couldn't even grieve properly.

You did grieve?

I did! It was a very sad moment. The MicroG Centre was born about a year later. One of the reasons, not the

> ## *Everything crashed so much inside me that, psychologically, the only thing I could do was to build something fresh from this destroyed dream.*

Assistant John Fletcher
Aleksandra Mir Studio

only reason, but one of the reasons is that everything crashed so much inside me that, psychologically, the only thing I could do was to build something fresh from this destroyed dream over which I had the control. I decided to create something within Brazil, which also aimed for international success, in an area for which Brazil was not well known – maybe subconsciously to prove that I should have been given a chance for the job.

Are you vindicated today?

Partially, yes. The centre is a success at an international level. But I still think it would have been fairer had they opened up the application process to all qualified people. By closing doors they excluded many groups, primarily women, since most, if not all of the candidates were men. I am not saying I should have got the job or I would have been the better qualified. But I spent many, many years of my life studying and working hard to get closer to my dream, spending years abroad, passing exams in a second language, succeeding as a Latin woman in a military and male-dominated field, only to find I was not allowed to compete... It could become a movie, huh?

It *is* a movie. The determination and ethos of *I am going to build something out of the ashes* is a powerful narrative. How many people are now linked to the centre?

It varies during the year because the students come and go but in general terms, including the collaborators from outside of Brazil, I would say between 50 and 100 people. It started with me on a desk and a computer and now it is 700 sq m and soon to increase in size again. We are a big MicroG family now.

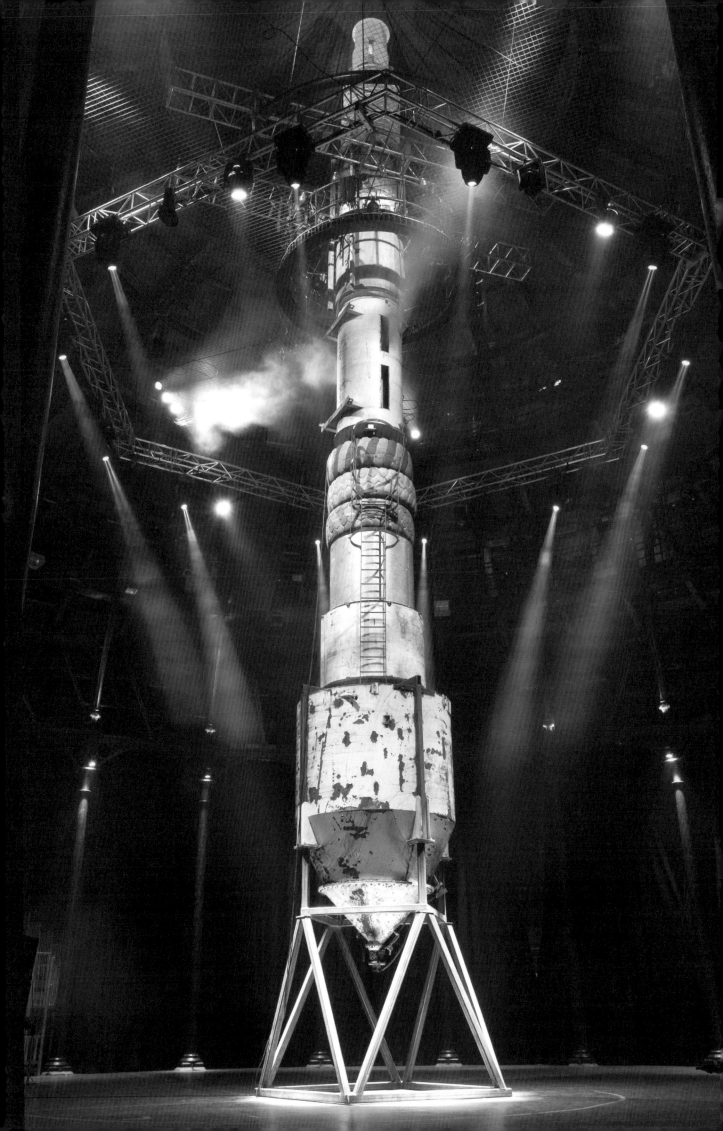

The interchangeable things

CHRIS WELCH *is a professor of astronautics and Space engineering at the International Space University in Strasbourg, France, where he is the Director of the interdisciplinary MSc in Space Studies. He likes Space a very great deal.*

ALEKSANDRA: Wow, you are surrounded with the best visuals in your office. I am taking a snapshot. How is it going?

CHRIS: Oh, it is a fairly full-on day here. I was a couple of minutes late getting to the computer as I was having a long conversation with a man from China who might become a lecturer here, if we can arrange it. This year we have a lot of Chinese students on the programme. One quarter of the class are Chinese – China is becoming a big Space player. We are trying to become more international. At the moment most of the faculty is European/American. It is important to become as international as we can.

Can you run a list of the students' nationalities from the top of your head?

This year, I think we have got 19 countries including France, Mexico, Spain, Venezuela, Namibia, Canada, USA, Italy, India, UK, Iraq, Russia, China of course, Turkey, Netherlands, Belgium... that's just this year. The year you were here, 2015, we had students from USA, Netherlands, France, Ireland, Romania, China, India, Morocco, Australia, Guatemala, UK, Estonia, Italy, Nigeria...

Do all these nationalities represent national Space programmes?

No, not at all. Most of the students have applied independently to come here. Some of them are supported by national Space agencies. The UK Space Agency supports the Brits. We have European Space Agency scholarships for Europeans. American students don't get direct NASA funding, though, and Canadian students don't get anything from the Canadian Space Agency either. The ISU is not attached directly to any state, so funding is very important.

Some students come from some very small countries.

Yes. Estonia is a very small country and Guatemala is also quite small.

Aleksandra Mir
GRAVITY
Produced by the Arts Catalyst,
Roundhouse, London, UK, 2006

Small, but relevant in Space terms?

Estonia is a relatively recent member of the European Space Agency. It has launched only one satellite, built by students, but it is a very technically innovative country. Skype – what we are using for this conversation – was originally invented by Estonians. They are less than 1.5 million people, but very connected, very aware of innovation and they are trying to develop their Space capabilities at their universities in both Tallinn and Tartu. We have a project here at the ISU on a Space habitat called *SHEE*. The actual habitat shell was built by the University of Tartu. The Estonian finance minister attended one of our short courses here at ISU. As a result, here is my Estonian e-residency card. The Estonian government knows who I am, so I can set up a company in Estonia, I can open a bank account and pay my taxes there but I never need to go there. It is all online.

What are you exploring?

Right now, I find it interesting, the way that notions of our nationhood are being played with a little bit.

Could we one day abandon nationhood completely?

I can see some signs that nations might change. There is the Asgardia project which calls itself a new Space nation. Five hundred thousand people have signed up for it. It was launched at a press conference in Paris and I happened to be there. There are all sorts of questions about it but my main reason for supporting it is that I think it expands the human imagination.

So it can't really happen?

The United Nations' definition of a nation is that it has to have territory.

What other Space initiatives come from small territories? A student of yours invited me to a Space festival on La Réunion, an island in the Indian Ocean.

La Réunion is a Department of France. The main Space related activity there I know of personally are some experiments to do with transmitting power through Space by microwaves. These were effectively created and facilitated by a man called Guy Pignolet, who used to be with CNES. There have been various related proposals at different times, from building giant solar-powered satellites to beaming power down from Space for us on Earth. Microwaves or lasers, but first you need to prove that you can transmit power through Space, which is why they did some tests in La Réunion.

With more diverse Space players and locations there is this growing sense of democratisation in Space. Can small Space nations truly compete?

Obviously when you have a small country there is a limit to how much high tech industry you can have. The students who designed and built Estonia's first satellite set up their own company when they graduated. That's very much where things are going in Europe and America and similarly in Israel – small, disruptive startups. ESA now has a network of business incubators, designed to transfer Space technology out of the Space sector. At the same time, other people are coming up with their own ideas independently and are setting up companies.

What about your African and South American students? What do they go back to when they graduate?

Some of them go back and some don't. We had one student from Guatemala. He did his internship with SAS, the satellite communications company in Luxembourg, then he came back here and carried out a second year thesis project on a topic defined by SAS where he then got a permanent job. But at the same time, he has been back to Guatemala and did very good work promoting the development of the first World Space Week there, coordinating stuff he had set up between universities and government agencies.

International students performing go-between roles.

ISU students and graduates as a group are the sort of people who want to push the agenda forward. They may do it by setting up a company or they may do it by undertaking Space education, outreach or communicating Space in other ways. The whole

> ## *ISU students and graduates as a group are the sort of people who want to push the agenda forward.*

purpose of the programme is to bring together diverse viewpoints and use those to new effect. We teach Space Engineering, Space Science, Space Applications, Space Policy, Economics and Law, Space Management and Business, Human Performance in Space and Space Humanities.

How did the programme form?

ISU is about to celebrate its 30th anniversary. It was founded… let me go and get this off the wall… this here is a copy of the ISU Credo that says… we the founders of… hereby set forth this credo… peaceful, prosperous and… benefit for all humanity… I am not going to read the whole thing, it is on our web site, but you get the idea. It is very much about being multidisciplinary.

The humanities have a very natural presence here. It makes the typical divide between STEM and everything else seem forcefully constructed. How did we get to this?

Back before the Renaissance period, if we are looking at it from a western perspective, people rarely divided knowledge up into different subjects. There wasn't so much of it, so maybe it was rarely a concern. People knew a lot less, overall. The amounts of knowledge accessible later increased very substantially and it became impossible for any one person to know everything and so inevitably you started to get some sort of differentiation. Groups started to split up and this is where, and although people don't necessarily realise it, you develop different cultures. The engineers have their engineering culture and then they become self-referential. You get groups of people who use the same language, think the same way, develop the same techniques. And if you run that forward, you get these self-fulfilling and self-perpetuating structures.

Tribes.

Then one tribe finds their knowledge is particularly useful – cue the Industrial Revolution. All this science and technical stuff suddenly develops the ability to generate large amounts of money and power for those people who know how to use it. Technical subjects become more valuable because you can directly transfer knowledge of

thermodynamics into money, while writing a poem might not be so profitable. So then it comes down to how much worth an individual and a society puts on these things.

Differentiation is easy, so why do we connect?

The poets and the engineers don't necessarily need to have any contact with each other, but then you reach a stage where things become even more complicated and you have to look outside your own discipline, because there are some problems which cannot be solved by a pure mono-disciplinary approach. All these disciplines are essentially just models of the Universe, with a particular tool set to do a particular thing. And if you insist that everything can be solved by one particular tool set, then in my opinion, you are missing something. I think this is becoming more generally acknowledged. Of course there is a need for specialists, but there is a need also for people who connect things together.

How do we identify and evaluate their contribution?

It is harder of course. Historically, if you want to be a professor at a university, you become successful by being narrow and focused in your research. Human beings tend to measure things that are easy to measure, money, or number of publications. The interchangeable things,

Technical subjects become more valuable because you can directly transfer knowledge of thermodynamics into money, while writing a poem might not be so profitable. So then it comes down to how much worth an individual and a society puts on these things.

that are more difficult to measure, don't get assessed. I tell my students that engineering is about numbers. In engineering, if you can't measure it, it doesn't exist, but that is not appropriate to say for other disciplines.

And how do you shift that, socially?

My students get lectures from artists, journalists, designers or anthropologists, and that is to stimulate different sorts of thinking, because if you just hang out with the same people and follow the same approach, you tend to get the same answers. I know people in the scientific and technical domain that are extremely competent but find it almost impossible to imagine anything outside of their domains. They see everything through a particular set of filters and a particular set of value judgments.

The organisation of compact disciplines seems more to do with social impulses than anything inherent to those disciplines. We want a community and validation from our peers. We want a club to go to.

Something like that. Not being an anthropologist, I don't have the right mental tools to be able to describe and to discuss that. One of the things about being interdisciplinary is that you can look at things and say, *I think there is something behind this but I do not personally have the education in order to be able to conceptualise it in an effective way.* Last week, we had an aerospace engineer who then had done an MA in anthropology and works for NASA. She came in to talk about why people should be interested in anthropology.

Why should they?

When you are a fish, you don't think about water. When you are in a culture, you don't necessarily think about the culture you are in. The challenge of being intercultural is that you even understand that there *are* different cultures and you have to be prepared to let yourself bleed out a bit. If you see your discipline in sharp resolution, you have to be prepared to let those edges soften a bit, whether it means to be international or interdisciplinary, all that stuff can go quite fuzzy about the edges. Some people are quite happy to do that and some people find it quite threatening.

You invite people like myself, artists. People who represent the arts and humanities in general but also people who can be quite extreme in their practices, in relation to what traditional engineering might be or what students would expect from their education. Is there any risk that some of what we bring, more than just stimulate thought, could also be a pure contradiction of what you are aiming for here, even a kind of sabotage? I mean, you are educating rocket engineers. Aren't you afraid that we might corrupt their minds in some ways?

You could only corrupt their minds if something you were going to do or made them think was bad, so no. If you succeeded in persuading an engineer to become an artist, I'd think, *let's see how that looks in action, go!*

It wouldn't be just about numbers anymore.

It is about people embracing the possibility of change. Young people tend to believe sometimes that they are defined by their first degree. But it is just a first degree and then you use that and you go and you do other things with it. Maybe you stay in the same field, maybe you don't.

When you invited me to give a workshop I asked your students to bring some empty food containers from their own kitchens and challenged them to build something akin to a rocket, a tall structure that could hold itself up with nothing but gravity. No glue, screws or external support. The purpose was to make them fail, as inevitably these creations would topple over, and then have them start again and build even higher, just to see it fall over again, while all their mates were laughing. What do you think the benefit of that exercise was?

Failure and Risk are very important to engineering. The purpose of engineering is primarily to reduce risk to zero. Science is about investigating our sense of curiosity. Engineering is about taking physical principles and controlling them to give you something predictable. So a lot of engineering is about assessing risk, about reducing risk and about controlling risk. And so from that point of view, there is a tendency to default in thinking about risk as a *bad thing*, while in fact risk is just a factor.

> ## *What your workshop did was to give them a very direct confrontation with risk. You can have fun with risk. It is a resource.*

The psychology around this is very interesting. Failure can be humiliating, or not, if you know how to use it.

You can't get rid of risk completely, but what you can do, is to examine your own attitude to it and decide how to use it and decide what level of risk you are prepared to accept, while trying to solve a particular problem. Under certain circumstances it is fine to accept a higher level of risk if you trade it off against something else. If you want to do something really cheaply, you can take a big risk. If you want to absolutely minimise risk then you are going to have to spend a lot of money. That is a very simple relationship between the two. And that applies to Space missions of all sorts. The attitude that one takes towards a human spacecraft for example is completely different to the attitude you might take towards a small cubesat built by students where the risk is obviously higher because you haven't spent that much time or money on it. It is that sort of

understanding. And what your workshop did was to give them a very direct confrontation with risk. You can have fun with *risk*. It is a resource.

The very useful uselessness of art.

To get people to deliberately build something that will fail, and to get them to almost embrace the risk, I think is important. Because another area where risk is important is if you are trying to set up a company. You have to be prepared to take a risk if you want to be a successful entrepreneur because you can't control all the factors. And if you are an investor, you think of it in terms of financial risk. I have met some investors who say that they will not invest in somebody who hasn't failed at least once, because if you have your own startup and you fail, you learn some useful lessons.

The investors don't want to be the people who will fund the first startup. They want to fund it when you've learned your lesson from failing once already.

Artists always rave about the risks we take. But art is a very cheap risk exercise.

Because at the end of day you know these soup cans are going to fall down so it is an exercise in learning how close you are willing to go to a boundary, knowing that ultimately *you are going to fail*. And that has more philosophical implications for Space, because going to Space is difficult and things do go wrong. Anybody who says they are going to send people to Space and it is all going to be wonderful is either a fool or they are lying.

Getting things to Space is difficult and sometimes things will blow up and people will die. That's just the way it is going to be.

The whole history of Space, aviation and before that ballooning – every time we took a jump and challenged gravity – could be written as a history of disasters where we have risked, failed, learned, risen and then progressed very rapidly, yet we are still expected to be embarrassed and humiliated by failure. For me, the most interesting outcome of the workshop was the students' handling of the embarrassment that comes with failure, their acting it out, by laughing.

Yes, we had lots of fun.

I saw ESA's general Director General Jan Woerner give a talk to a room full of people shortly after the Schiaparelli Mars lander crashed on Mars. He handled it with wit and elegance, it was very impressive to watch. Not only was it educational to bring up the crash, to make people understand what had been achieved thanks to the mission up until the very last seconds when the landing gear did not unfold correctly. But it was the way he handled the moment of expected embarrassment, by riding the wave and undermining assumptions, pausing for effect and cracking a joke. *Now we have a permanent base on Mars!* The room laughed, the issue dissipated and everyone moved on, trusting him to lead the next mission. It was brilliant.

Yes, because all good engineers have seen things go wrong. The public might *want* absolute safety from their train system but you can't have absolute safety. I am going to Germany on the train tomorrow, the ticket is about 100 Euro return and there is a chance of me dying on that train, hopefully a small chance, but still… Now, they could make it much safer, they could give me a safety belt, airbags, insist that I can't stand up and walk around the train. They can put in advanced signalling and instead of paying 100 Euro, I could be paying 1,000 Euro for my ticket to travel 50 km – in which case I just wouldn't go. Or if I wanted to get there very safely, I would walk. So implicitly, I am accepting a certain level of risk when I get on the train.

Or send a probe to Mars.

A lot of risk is linked to speed. Kinetic energy is proportional to the square of velocity so if I walk across the room and into the door it might hurt my nose a bit. If I run into the door it will hurt a lot more. If I bicycle into a wall I will break my wrist (I know, because I have done that). If I am in a car that goes 40 miles an hour I can suffer serious injury and if it is 100 miles an hour in a crash, I am dead. It is this desire for humans to get from one place to another. It is the same thing with your phone. You have got all that energy in a battery and it is fine if it comes out a little bit at a time, but if it all

comes out in one go, it will catch fire and you may have an explosion. You see exactly this is in the Samsung Galaxy phones.

You have one of the sunniest and most positive outlooks.

Even on a bad day.

Even on a bad day, and I ascribe that to you simply being around young optimistic people on a daily basis. But you also have what I perceive as a very dark vision of the fate of humanity, which then leads to the necessity, as you have described it, to leave our planet. How is that even compatible with being an educator?

My first degree was in physics and I got into that through studying astronomy – when I was a teenager I was really interested in Cosmology. So my initial interest in Space was, *where did the Universe come from and what's going to happen at the end of it?* At a fairly early stage I got used to thinking on big timescales and accustomed to the idea that the Universe was going to end at some point, although I probably wouldn't be around to see it. And then it is actually a very small step backwards to accept the fact that in due course, the Sun is going to turn into a red giant some billions of years from now and expand to swallow up the Earth. I mean, that is *the nature of the Universe.* Things change and you don't always like the way they do. People have a slightly romantic idea of the Earth but the Universe doesn't owe us a living and we should pay more attention to the way the Universe is. If you look at it in a sober way we know that if humanity stays on Earth, it will disappear.

But if humans are shaped by our relationship to Earth, why not just go down with it?

I like human beings, in general, most of them, and I would like to see the species continue. Now, there are no guarantees, no promises that travelling into Space will guarantee the survival of humanity. Right in this moment, a more fundamental question for me is *What's the future for western liberal democracy?* Before we get into the *What's the future for humanity?* Here is a cheerful book to read, *Global Catastrophic Risks,* about existential risks to humanity. It has been put out by the Future of Humanity Institute in Oxford who look at things like response to apocalyptic threats, cognitive biases that affect judgment of global risks, risks from nature, comets, super volcanoes, supernovae, climate change, plagues, pandemics, artificial intelligence, social collapse, nuclear war, nuclear terrorism, biotechnology, nanotechnology and totalitarianism.

> *This is human beings coming to terms with the human condition. We live and we die and what do we leave behind?*

So that's what you read in bed and you still have reason to get up in the morning?

I did realise it was giving me rather strange dreams. But I mean, this is human beings coming to terms with the human condition. We live and we die and what do we leave behind? Fundamentally, I think we have to try hard to be positive. You have got to stay in motion, keep doing things, stay engaged. Although I am dressed in black, I am not actually a Goth :)

What else is the Space world looking forward to?

We are moving towards a democratisation of Space. If you want to go to the International Space Station today, you can. You just need 25 million dollars to pay for it. So if you are rich enough, you can go to Space. Before, the only way to do it was to do it through a government and now you can go to Space Adventures Ltd. The business approach itself obviously has issues, but the point is you can in principle go to a web site with a credit card and book yourself a parabolic flight, something that in the past only military pilots or trainee astronauts would have the opportunity to do.

The prospect of Space tourism changes the game.

Because it is difficult and expensive to go to Space, traditionally the only two solidly accepted reasons for going were Science and Military. We are only now seeing that dissolve in favour of people who just want to go because they are curious or want the experience, like going to Florida.

Master of Space Studies students, future Space engineers and Space communicators, participate in Aleksandra Mir's *Failing and Falling: A Workshop on Gravity* International Space University, Strasbourg, 2015

Thank You!

| CONTRIBUTORS

ALICE GORMAN
Flinders University,
Adelaide

ANDREA MORETTI
Inmarsat, London

ANDREW KUH,
UK Space Agency,
Swindon

CHRIS WELCH
International Space
University, Strasbourg

CLARA SOUSA-SILVA
Massachusetts Institute
of Technology, Cambridge

DELIA DI FILIPPANTONIO
Satellite Applications
Catapult, Harwell

HELEN FRASER
Open University,
Milton Keynes

JAN WOERNER
European Space Agency,
Paris

JAYANNE ENGLISH
University of Manitoba,
Winnipeg

JILL STUART
METI International,
San Francisco; London
School of Economics

MAREK KUKULA
Royal Observatory
Greenwich, London

MATTHEW STUTTARD
Airbus Defence & Space,
Stevenage

REBECCA CHARNOCK
Aberystwyth University,
Wales

SANJEEV GUPTA
Imperial College,
London; NASA Curiosity
Rover Mission,
Jet Propulsion
Laboratory,
Pasadena

STUART EVES
Surrey Satellite
Technology LTD,
Guildford

THAIS RUSSOMANO
MicroG Centre, PUCRS
University,
Porto Alegre

| STUDIO ASSISTANTS

Aliyah Coreana
Anna Lytridou
Anna Rekas
Anna Salomon
Arielle Tse
David Maina
Denis Shankey
Esi Essel
Grace Kaluba
Inês Ferreira
Ioana Pioaru
Joana Groba
Joanna Rogers

Joanna Vanderpuije
Jerome Ince-Mitchell
John Fletcher
Kayleigh Handley
Laura Jones
Laura Moreton-Griffiths
Lola Moreton-Griffiths
Moira Lam
Simone Russell
Radu Nastasia
Yasmin Falahat

| SPECIAL THANKS

Andy Thompson
Anna Lynch
Brian Tittley
Doug Millard
Ellen Wettmark
Emma Smith
Franco Bonacina
Grace Beaumont
Jane Chao
Jason Read
João Rangel de Almeida
Jonathan Roson
Jonathan Sinnatt
Ken Hollings
Kevin Perreira
Louise Devoy
Margherita Buoso
Mark Pilkington

Melanie Vandenbrouck
Michele Robecchi
Monica Chung
Natalia Sidlina
Oleg Ventskovsky
Phoebe Harkins
Ralph Rugoff
Ross MacFarlane
Sian Prosser
Silke Ackerman
Scott Hatton
Stephen Johnston
Susan Buckle
Tihana Šare
Tim McGill
Tom Bloxham
Yas Mostashari Chang

TATE LIVERPOOL

Francesco Manacorda, Artistic Director
Tamar Hemmes, Assistant Curator
Lindsey Fryer, Head of Learning
Mike Pinnington, Content Editor
Jemima Pyne, Head of Media and Audiences
Alison Cornmell, Communications Manager
Dominic Beaumont, Communications Manager
Laura Deveney, Communications Assistant
Jennifer Marley, Marketing Manager
Jo Warmington, Head of Development
Dan Smernicki, Registrar
Ken Simons, Art Handling Manager
Barry Bentley, Deputy Art Handling Manager

MODERN ART OXFORD

Paul Hobson, Director
Verity Slater, Director, Development and Communications
Emma Ridgway, Head of Programme
Helen Shilton, Head of Operations and Visitor Services
Stephanie Straine, Curator, Exhibitions and Projects
Sara Lowes, Curator, Creative Learning
Scot Blyth, Production Manager
Andy Owen, Assistant Production Manager
Jonathan Weston, Programme Coordinator
Ruba Asfahani, Communications Manager
Clare Stimpson, Communications Manager
Liz Smith, Development Manager
Andree Latham, Development and Communications Coordinator

Strange Attractor Press 2017